TREASURES OF THE CIVIL WAR ★

Legendary Leaders Who Shaped a War and a Nation

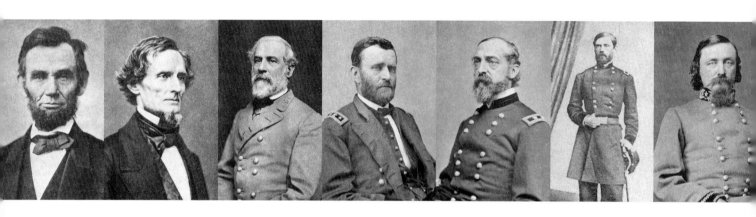

ROWMAN & LITTLEFIELD PUBLISHERS, INC.
Lanham · Boulder · New York · Toronto · Plymouth, UK

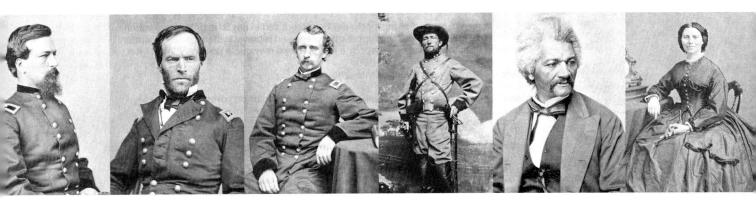

TREASURES OF THE CIVIL WAR ★

Legendary Leaders Who Shaped a War and a Nation

Published by Rowman & Littlefield Publishers, Inc.
A wholly owned subsidary of The Rowman & Littlefield Publishing Group, Inc.
4501 Forbes Boulevard, Suite 200, Lanham, Maryland 20706
www.rowman.com

10 Thornbury Road, Plymouth PL6 7PP, United Kingdom

Historical photographs as credited throughout

Historical photographs of Union General John Fulton Reynolds on cover, title page and page 4 courtesy of the Archives and Special Collections, Franklin and Marshall College, Lancaster, Pennsylvania

All other historical photography courtesy of the Library of Congress and National Park Service

British Library Cataloguing in Publication Information Available

Library of Congress Cataloging-in-Publication Data Available

ISBN 978-1-4422-2398-1 (cloth : alk. paper)

∞™ The paper used in this publication meets the minimum requirements of American National Standard for Information Sciences—Permanence of Paper for Printed Library Materials, ANSI/NISO Z39.48-1992.

Printed in the United States of America

Exhibit and Book Project Team

Gettysburg National Military Park/National Park Service
R. Gregory Goodell, Museum Services Supervisor
D. Scott Hartwig, Supervisory Historian

Gettysburg Foundation
Daniel M. Bringman, Chief Financial Officer
Cindy L. Small, Director, Marketing and Communications

Design
The 1717 Design Group
John C. Crank, Principal Designer
Jena L. Bright, Senior Designer
Katie G. Slusher, Senior Designer

Writer/Editor
Renae H. MacLachlan

Interpretive Planning Consultant
Robin E. Reed

Original Photography
Bill Dowling

Curatorial and Research Assistant
Jennifer Pratt Weaver

This special *Treasures of the Civil War* exhibit is made possible through a gift from the Texas Civil War Museum

Institutions contributing artifacts to
Treasures of the Civil War include:

Civil War Museum of Philadelphia

Gilder Lehrman Institute of American History

The Craig Bashein Collection

National Park Service

 Arlington House, The Robert E. Lee Memorial

 Clara Barton National Historic Site

 Frederick Douglass National Historic Site

 Gettysburg National Military Park

Smithsonian Institution, National Museum of American History, Kenneth E. Behring Center

U.S. General Services Administration, Public Buildings Service

IN GRATITUDE
The 150th Anniversary of Gettysburg

The commemoration of the 150th Anniversary of the Battle of Gettysburg and the Gettysburg Address are historic events that will touch millions of individuals throughout the country and the world. Thanks to the generous support of our supporters and partners, the Gettysburg Foundation and Gettysburg National Military Park can build a future where the stories and sacrifices of Gettysburg are not only known, but also cherished and passed on for the next 150 years and beyond.

The Gettysburg Foundation gratefully acknowledges the following partners who are helping to ensure that the commemoration of the 150th Anniversary of Gettysburg is a memorable and successful time in America's history:

Church & Dwight Co., Inc.

Event Network, Inc.

The Hershey Company

M & T Bank

ARAMARK

The Coca-Cola Company

Giant Food Stores

Landfall Navigation

PNC Bank

Trader Joe's

TABLE OF CONTENTS

FOREWORD
A story both poignant and valorous

With sesquicentennial commemorations of the Civil War entering their third year in 2013, we observe the 150th anniversary of the Emancipation Proclamation, the Battle of Gettysburg, the fall of Vicksburg, the first battles in which black Union soldiers fought, Abraham Lincoln's Gettysburg Address, and other important events during the momentous year of 1863. Thus it is altogether fitting that a new exhibit featuring thirteen of the principal leaders in that transformative conflict which changed America opens at the museum of the Gettysburg National Military Park Visitor Center. The exhibit, and this catalog, bring visitors and readers closer to those people and the events they shaped.

We sometimes forget that these seemingly larger-than-life leaders like Lincoln, Lee, Grant, Sherman, and the others represented in this exhibit were human beings who experienced failures as well as successes and shared the traits and foibles and emotions common to all of us. *Treasures of the Civil War* focuses on the human side of their personalities. It helps us appreciate that while they were talented individuals who rose to greatness by meeting the challenges of the extraordinary times in which they lived, they were also flesh-and-blood people just like us. To know them better helps us to understand the history they made and how it continues to influence the world in which we live.

The exhibit accomplishes this purpose through several different types of presentation. The science of photography, relatively new in the 1860s, enables us to see what these people actually looked like. Woodcut illustrations, cartoons, illustrated postcards and envelopes, and sheet music show us how they were portrayed—heroically, satirically, lightheartedly—in the popular culture of the time. The panels featuring personal highlights of the leaders tell us, among other interesting

details, that Lincoln established the precedent of a presidential pardon of a turkey at Thanksgiving, that Jefferson Davis' youngest child, born during the Civil War, became known as "The Daughter of the Confederacy," that General Lee had a pet hen who reportedly accompanied him during the war, that General Grant enjoyed sliced cucumbers in vinegar for breakfast, that General George G. Meade was nearsighted (his glasses are on exhibit), that General John Reynolds has three monuments at Gettysburg plus a statue on the Pennsylvania monument there, that General George Pickett perfumed his hair and beard, that General Alexander Webb who commanded the troops that fought against Pickett's Charge had a grandfather who fought at Bunker Hill in the American Revolution, that a granddaughter of General Sherman married a grandson of Confederate General Lewis Armistead, who was mortally wounded in Pickett's Charge, that General Custer had eleven horses shot under him during the Civil War, that guerrilla leader John Singleton Mosby had been expelled from the University of Virginia before the war for shooting a fellow student, that one of Frederick Douglass' twenty-one grandchildren was the first African-American concert violinist to play on several continents, and that many Civil War soldiers honored Clara Barton by naming their daughters after her.

Of greatest interest to most viewers, perhaps, are the three-dimensional artifacts associated with each of these thirteen individuals. These were the actual items belonging to, handled by, worn by, or written by them: letters, dispatches, proclamations, hats and boots, eyeglasses and field glasses, flags carried in battle, swords and sashes worn by generals, Grant's cigar case and a cigar owned by Jefferson Davis that was taken from him when he was captured at the end of the war, the saddle that reportedly carried General John Reynolds when he was killed at Gettysburg, a lock of Lincoln's hair, a lock of Lee's hair and of the mane of his famous horse Traveller. Each of these items tells a story that expands our knowledge about the person and,

collectively, about the war they fought as soldiers—nine of the thirteen—and as civilian leaders of government and opinion. Seven of the thirteen had a direct connection to Gettysburg: six as soldiers who fought there, and one, Lincoln, as a speaker at the dedication of the soldiers' cemetery.

The exhibit, and this catalog, can be likened to a mosaic. Each part has an intrinsic interest and meaning, while the whole offers a complex but clear picture of the Civil War portrayed through the biographies and personalities of some of its principal protagonists. They tell a story both poignant and valorous.

James M. McPherson
George Henry Davis 1886 Professor of American History, Emeritus
Princeton University

Gettysburg Foundation Board of Directors and Historians' Council

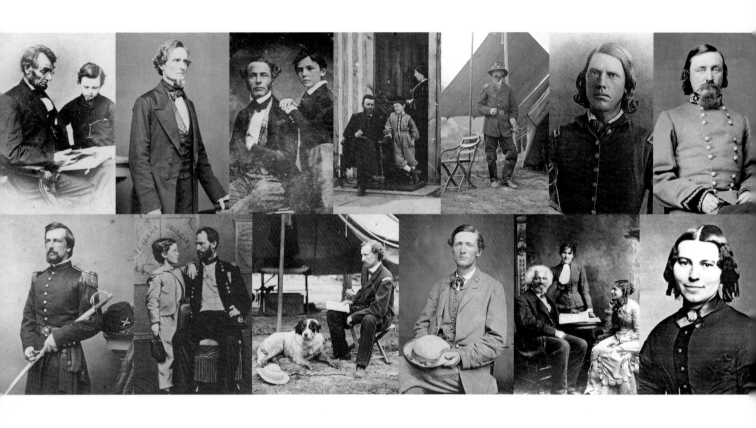

INTRODUCTION
The great task remaining before us

It took just four days in 1863 to etch Gettysburg into our national lexicon forever. From July 1 to 3, a Union victory in the largest battle ever fought in North America helped turn the tide of the war. One November morning four months later, President Abraham Lincoln dedicated the Soldiers' National Cemetery with his immortal address. In two minutes, our 16th President ushered in a new birth of freedom, proclaiming Gettysburg as a touchstone of our national identity.

The fate of our nation—not only at Gettysburg but throughout the entire Civil War—rested with a handful of political, military and cultural leaders. Well known in their day, their names still reverberate in the 21st century: Abraham Lincoln. Jefferson Davis. Robert E. Lee. Ulysses Grant. George Meade. John Reynolds. George Pickett. Alexander Webb. William Tecumseh Sherman. George Custer. John Mosby. Frederick Douglass. Clara Barton.

Some had formal wartime roles that demanded leadership of them; some had the challenges of leadership thrust upon them or tried to right a wrong or meet a need. Each vowed to create a more perfect country for their respective causes. All played a role in charting the future course of the nation during its greatest crisis.

To honor the efforts of these extraordinary leaders, and to commemorate the 150th Anniversary of the Battle of Gettysburg and Lincoln's Gettysburg Address, we have planned a distinctive exhibit and this accompanying limited-edition gallery book— both called *Treasures of the Civil War*.

Treasures of the Civil War reveals a rare, engaging glimpse into the professional and personal sides of several key wartime leaders— an up-close look at the giants who shaped today's America 150 years ago. Their stories unfold in two ways: through more

than 90 specially selected artifacts from Gettysburg National Military Park and other nationally renowned collections and through uniquely crafted presentations of images and information about the leaders' personal lives.

We chose leaders from distinct spheres of the war: political, military and social/cultural. Through their words, decisions and actions, the thirteen individuals whose objects we selected to showcase profoundly influenced the war. They also sculpted a new nation—whether they were in the saddle, behind a desk, on the front lines, in a tent hospital or in the town hall.

Many artifacts in the exhibit will remain for visitors to view through the conclusion of the sesquicentennial commemoration of the Civil War. Others will be rotated and replaced in 2014 and 2015 with objects that mirror the specific leaders' activities in the final two years of the war. This pivotal collection gives us the unique opportunity to come face to face with great Americans of yesterday and how they passed through the crucible of war to create the United States of today.

Just as the making of *Treasures of the Civil War* reflects a collaboration of and support from numerous organizations and individuals, the stewardship of Gettysburg is led by a strong and innovative partnership between Gettysburg National Military Park (GNMP) and the Gettysburg Foundation.

Meeting our visitors' needs and caring for a national treasure the size and scope and draw of Gettysburg is a monumental task—one performed by expert GNMP historians, interpreters, preservation specialists and staff—and one shared by the Gettysburg Foundation, the Park's non-profit partner since 1989.

Called a model for the entire NPS, this partnership combines the academic legacy, interpretive expertise, and preservation resources of Gettysburg National Military Park with the Foundation's valuable public outreach capabilities and private financial support. Building a new museum and visitor center

in 2008 was a major accomplishment of the partnership because it enabled the Park to better protect and preserve items from its Civil War collection—considered among the largest in the United States.

The partnership also makes possible the acquisition of new artifacts and conservation of existing ones, as well as the rotation and replacement of others from time to time—in order to enhance that interpretive platform. Each artifact is more than a valuable object; it is a link that reveals our greater American story. Protecting and enhancing collections and refreshing exhibits of these items makes that story accessible and available to all Americans and people from around the world.

The history of Gettysburg is vibrant and ever-changing. In its reach and relevance to our national narrative, Gettysburg unveils new information that moves our understanding forward every day. At Gettysburg National Military Park and the Gettysburg Foundation, we recognize that as much as Gettysburg has already taught about our national character in the past 150 years, it has much more to convey.

In bringing you this special *Treasures of the Civil War* collection in honor of Gettysburg's 150th Anniversary, we hope to provide powerful insight into who we were—and who we are—as a people and a nation.

Bob Kirby
Superintendent
Gettysburg National Military Park

Joanne M. Hanley
President
Gettysburg Foundation

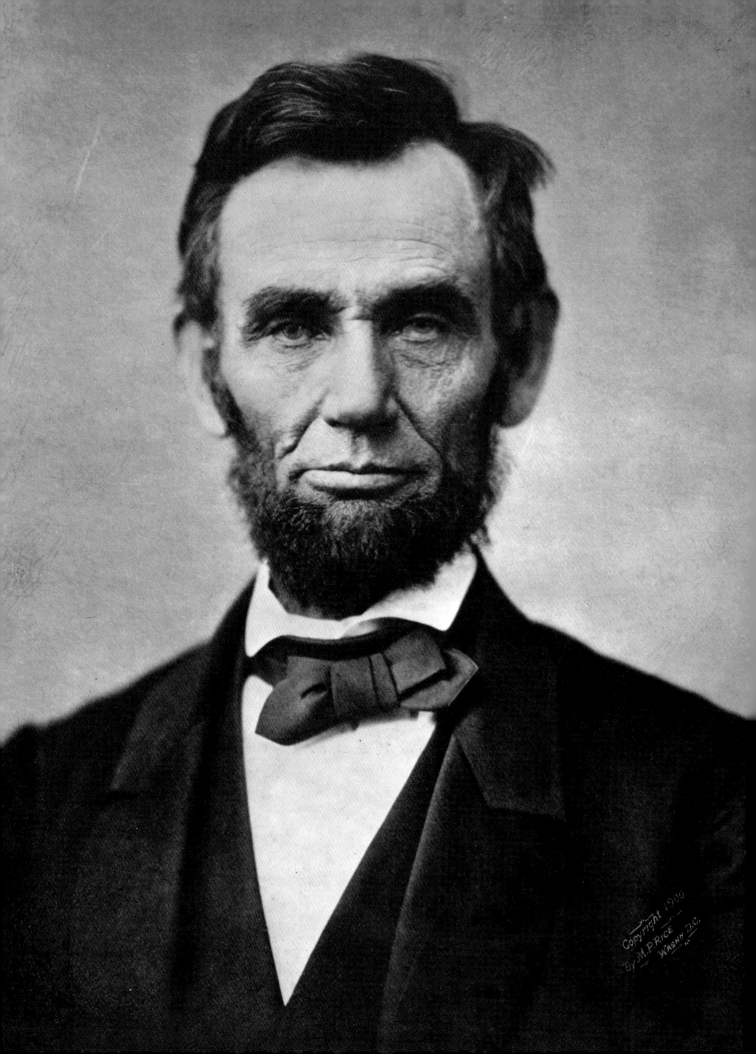

The Presidency, even to the most experienced politicians, is no bed of roses. No human being can fill that station and escape censure.

—Abraham Lincoln

ABRAHAM LINCOLN
1809–1865
16th President of the United States

The champion-in-chief of the United States, President Lincoln used his genius for leadership to prevent the country's collapse. He bent the law of the land to preserve it. He sought advice from political friend and foe alike. He formed a cabinet that opposed him, tapping into their ideas. He fired general after general, confident one would emerge to lead the Union to victory.

Lincoln's belief in Union and his constitutional role to defend it never faltered. While leading the country through its greatest crisis, he also took steps to strengthen its future. He spearheaded laws to support westward expansion, the transcontinental railroad and the national parks. In the midst of it all, the president managed to run his own re-election campaign— and started the holiday of Thanksgiving.

The most gifted communicator of all U.S. presidents, Lincoln used his talents to reunite and sculpt a new nation. He rebuked generals when they erred but admitted when he was wrong. He played a pivotal role in abolishing slavery, issuing the Emancipation Proclamation and freeing slaves in states in rebellion—then pushed Congress to outlaw slavery everywhere through the 13th Amendment. He proclaimed the nation's new birth of freedom in the Gettysburg Address.

And toward war's end, Lincoln set the tone for how Americans should move forward and rebuild—"with malice toward none, with charity for all."

ABRAHAM LINCOLN
1809–1865

Born
- Hardin County, Kentucky

Nicknames
- The Original Gorilla, Father Abraham, The Emancipator

Claim to fame
- 16th President of the United States, 1861–1865
- Saved and restored the Union
- Abolished slavery
- Emancipation Proclamation
- Gettysburg Address

Family
- Wife, Mary Ann Todd
- Four children, sons (only Robert lived to adulthood); son Willie died when Lincoln was president

Pets
- Jack the Turkey (pardoned, beginning tradition of president pardoning a turkey during the holidays); Fido and Jip the dogs; Nanny and Nanko, son Tad's goats; assorted ponies, rabbits and kittens

Personal trivia
- No middle name
- Did not smoke or drink alcohol
- First president born west of the Appalachian mountains
- Award-winning actor Tom Hanks is a distant relative (through Lincoln's mother's family)
- Suffered periods of depression and severe headaches
- Springfield, Illinois, neighbors said he fed and milked his own cows, fed and curried his own horse and took pride in chopping his own wood—even late into the night
- Didn't like to plant trees or gardens—one neighbor planted roses for him to liven up Lincoln's property

Horse
- Old Bob (Springfield, Illinois)

Personal characteristics
- Tall and lean (about 6 feet 4 inches tall, 180 lbs.), gray eyes, charcoal hair, mole on right cheek, beard starting in 1861
- High-pitched, shrill tenor voice

Favorite songs/artists
- "Dixie," "Listen to the Mockingbird," Mozart's "Magic Flute," Stephen Foster's "Annie Laurie," the opera "Martha" (performed at his second inaugural festivities) and the works of Southerner and composer/pianist Louis Moreau Gottschalk, who wrote "The Union (Fantasy on Patriotic Airs)"

Favorite foods
- Apples, bacon, chicken fricassee with biscuits, gingerbread (boyhood), biscuit/milk/fruit for lunch

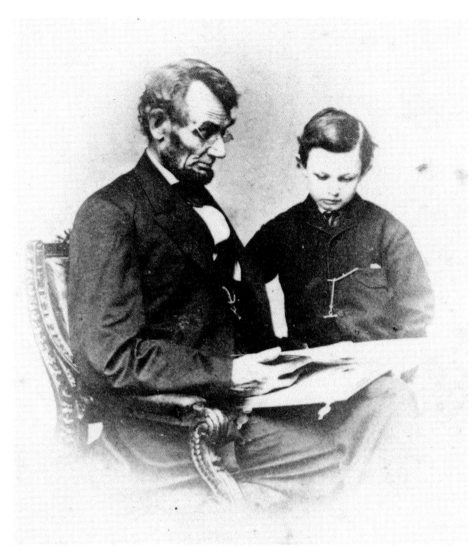

LEFT / Lincoln reading to son Thomas ("Tad"), 10, February 1864. Lincoln called him Tad because he resembled a tadpole at birth. The boy often interrupted White House meetings, irritating some staff and Cabinet officers. *Gilder Lehrman Institute of American History*

BELOW / Lincoln's father, Thomas. Lincoln was not close to him and did not attend his funeral.

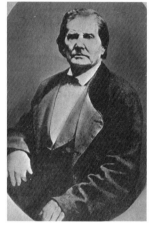

RIGHT / The president's mother, Nancy Hanks Lincoln, died when he was 9. *Courtesy of the Ostendorf Family*

FAR RIGHT / Sarah Bush Johnston, his stepmother. Lincoln's father remarried a year after his first wife's death. Sarah encouraged Lincoln to read. They became close— Lincoln called her "Mother."

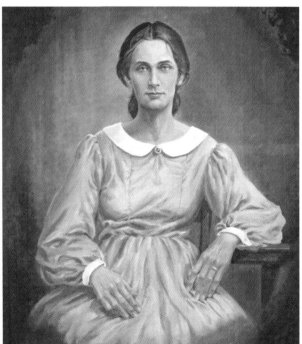

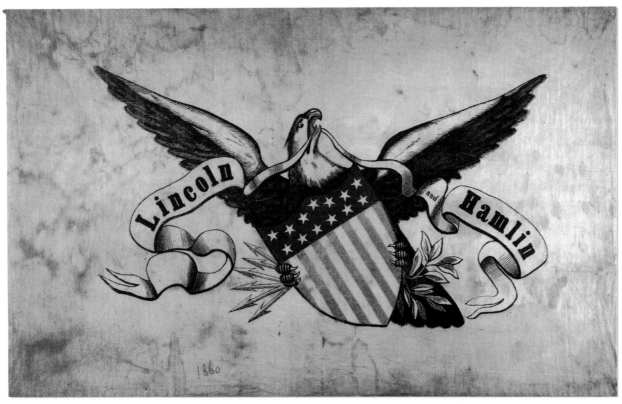

GLC 05553

ABOVE / *On the campaign trail*
This cloth banner from the 1860 presidential election
features Lincoln and Hannibal Hamlin, his vice presidential
running mate. Campaign banners often featured patriotic
symbols. This one has a portion of the Great Seal of the
United States, which then depicted only six arrows in the
eagle's talon instead of 13 to represent the original colonies
that formed the United States. *On loan from the Gilder
Lehrman Institute of American History*

RIGHT / *Preserve, protect, defend*
This printing of the president's inaugural address in
March 1861 shows Lincoln told the Washington crowd that
he did not plan to interfere with the institution of slavery.
He also spoke to the states that had threatened secession:
"In your hands, my dissatisfied fellow-countrymen, and not
in mine, is the momentous issue of civil war...You have
no oath registered in heaven to destroy the Government,
while I shall have the most solemn one to 'preserve, protect,
and defend it.'" *On loan from the Gilder Lehrman Institute
of American History*

Chicago Tribune
EXTRA.

MONDAY, MARCH 4, 1861.

INAUGURAL MESSAGE
OF
ABRAHAM LINCOLN,
President of the United States.

FELLOW CITIZENS OF THE UNITED STATES—In compliance with a custom as old as the Government itself, I appear before you to address you briefly, and to take, in your presence, the oath prescribed by the Constitution of the United States to be taken by the President before he enters on the execution of his office...

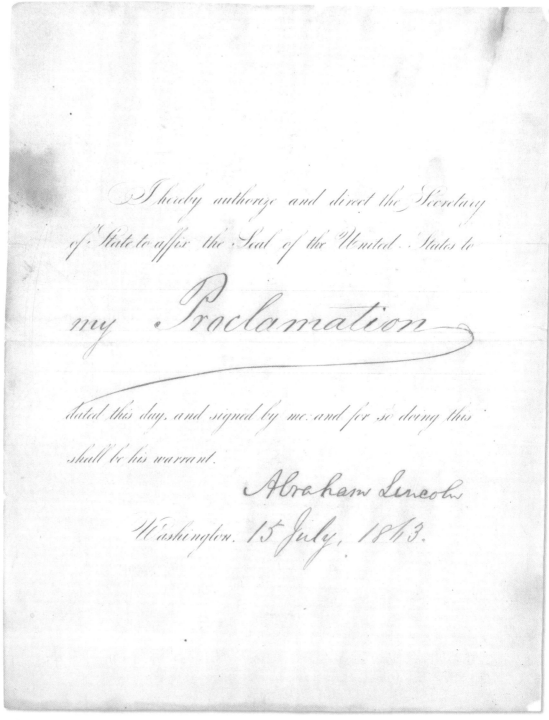

I hereby authorize and direct the Secretary of State to affix the Seal of the United States to

my Proclamation

dated this day, and signed by me: and for so doing this shall be his warrant.

Abraham Lincoln
Washington. 15 July, 1863.

GLC 06754

Giving thanks

To celebrate the Union victories at Gettysburg and Vicksburg—major turning points of the war— Lincoln proclaimed a national day of Thanksgiving. In his August 6, 1863, declaration, Lincoln asked for God's intervention to "subdue the anger which has produced... a needless and cruel rebellion." *On loan from the Gilder Lehrman Institute of American History*

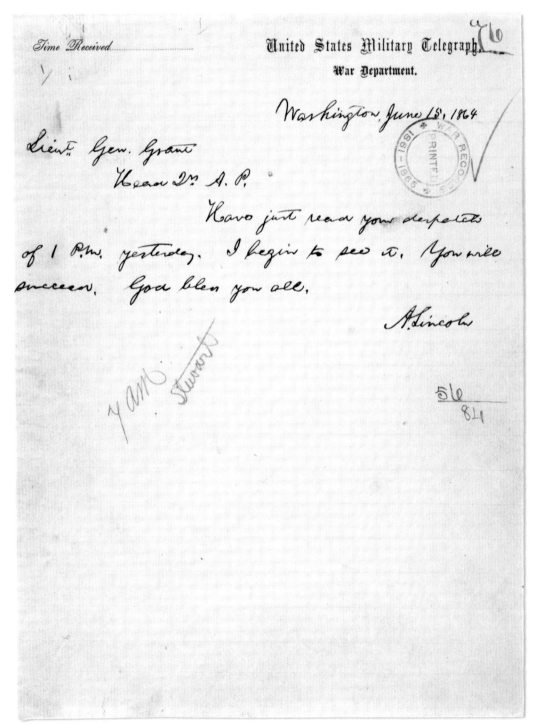

"I begin to see it"

Lincoln wrote this brief message encouraging Ulysses Grant, General-in-Chief of all Union armies, on June 15, 1864, predicting a victory in the war. The president wrote, "You will succeed. God bless you all." *On loan from the Gilder Lehrman Institute of American History*

39

At the last session of Congress a proposed amendment of the Constitution, abolishing slavery throughout the United States, passed the Senate, but failed for lack of the requisite two thirds vote in the House of Representatives. Although the present is the same congress, and nearly the same members, and without questioning the wisdom or patriotism of those who stood in opposition, I venture to recommend the reconsideration and passage of the measure at the present session.

GLC 08094

ABOVE / *Gone for good*
In the president's final State of the Union address December 6, 1864, he urged Congress to pass the 13th Amendment to the Constitution, which would abolish slavery throughout the country. Although he had outlawed slavery in the states in rebellion through the Emancipation Proclamation, Lincoln wanted to ensure that slavery was eliminated in every state—which it was, the year after he gave this speech. *On loan from the Gilder Lehrman Institute of American History*

RIGHT / *Making a stand*
Traveling to Washington, D.C., for his inauguration, President-Elect Lincoln raised a flag (of which this fragment is a part) in front of Philadelphia's Independence Hall. Lincoln gave an impromptu speech, saying "I have never had a feeling politically that did not spring from the sentiments embodied in the Declaration of Independence." He also said he would rather be assassinated on the spot than surrender the liberty the Declaration gave to the country. *On loan from the Civil War Museum of Philadelphia*

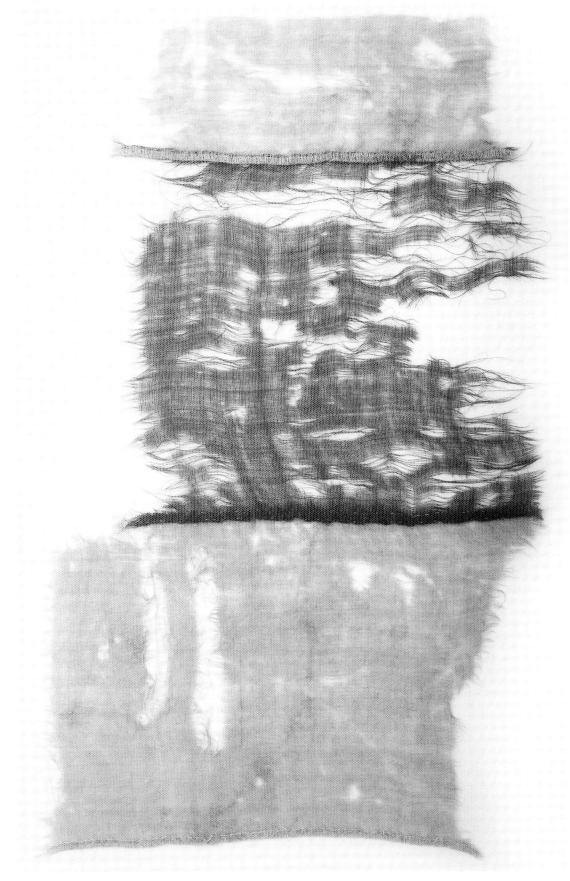

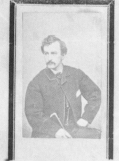
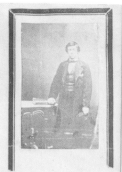

SURRAT. BOOTH. HAROLD.

War Department, Washington, April 20, 1865,

 # $100,000 REWARD!

THE MURDERER

Of our late beloved President, Abraham Lincoln,

IS STILL AT LARGE.

$50,000 REWARD

Will be paid by this Department for his apprehension, in addition to any reward offered by Municipal Authorities or State Executives.

$25,000 REWARD

Will be paid for the apprehension of JOHN H. SURRATT, one of Booth's Accomplices.

$25,000 REWARD

Will be paid for the apprehension of David C. Harold, another of Booth's accomplices.

LIBERAL REWARDS will be paid for any information that shall conduce to the arrest of either of the above-named criminals, or their accomplices.

All persons harboring or secreting the said persons, or either of them, or aiding or assisting their concealment or escape, will be treated as accomplices in the murder of the President and the attempted assassination of the Secretary of State, and shall be subject to trial before a Military Commission and the punishment of DEATH.

Let the stain of innocent blood be removed from the land by the arrest and punishment of the murderers.

All good citizens are exhorted to aid public justice on this occasion. Every man should consider his own conscience charged with this solemn duty, and rest neither night nor day until it be accomplished.

EDWIN M. STANTON, Secretary of War.

DESCRIPTIONS.—BOOTH is Five Feet 7 or 8 inches high, slender build, high forehead, black hair, black eyes, and wears a heavy black moustache.

JOHN H. SURRAT is about 5 feet, 9 inches. Hair rather thin and dark; eyes rather light; no beard. Would weigh 145 or 150 pounds. Complexion rather pale and clear, with color in his cheeks. Wore light clothes of fine quality. Shoulders square; cheek bones rather prominent; chin narrow; ears projecting at the top; forehead rather low and square, but broad. Parts his hair on the right side; neck rather long. His lips are firmly set. A slim man.

DAVID C. HAROLD is five feet six inches high, hair dark, eyes dark, eyebrows rather heavy, full face, nose short, hand short and fleshy, feet small, instep high, round bodied, naturally quick and active, slightly closes his eyes when looking at a person.

NOTICE.—In addition to the above, State and other authorities have offered rewards amounting to almost one hundred thousand dollars, making an aggregate of about TWO HUNDRED THOUSAND DOLLARS.

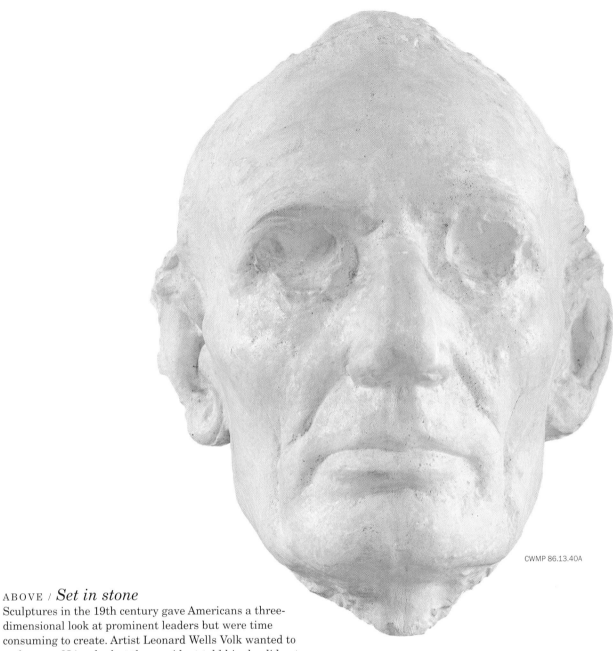

CWMP 86.13.40A

ABOVE / *Set in stone*
Sculptures in the 19th century gave Americans a three-dimensional look at prominent leaders but were time consuming to create. Artist Leonard Wells Volk wanted to make one of Lincoln, but the president told him he did not have the time. Volk instead suggested a quicker method of capturing Lincoln's likeness—a plaster cast of his face. Lincoln agreed. Volk was the cousin of the wife of Lincoln's opponent in the 1860 election—U.S. Sen. Stephen Douglas. *On loan from the Civil War Museum of Philadelphia*

LEFT / *Wanted*
Rocked by Lincoln's assassination, officials swiftly organized pursuit of those responsible. Within five days they published this poster seeking his murderers. Devised by John Wilkes Booth, the original plot called for Lincoln's kidnapping. Once Booth learned that Lincoln planned to give African Americans citizenship, he decided to kill him. Six days after this poster was printed, Union soldiers caught and killed Booth in Virginia. Four conspirators were hanged July 7, 1865. *On loan from the Civil War Museum of Philadelphia*

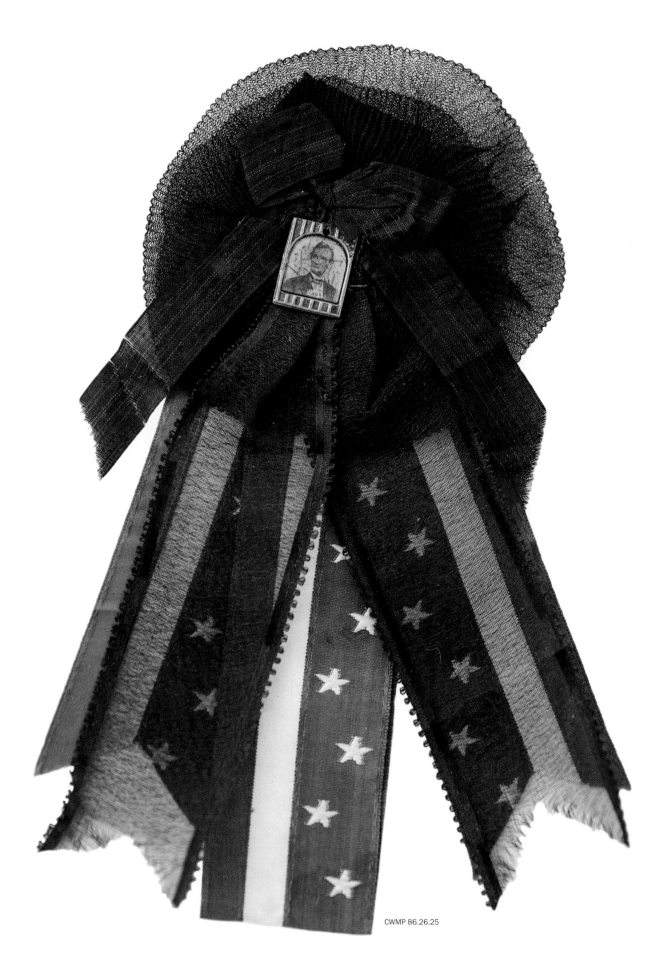

CWMP 86.26.25

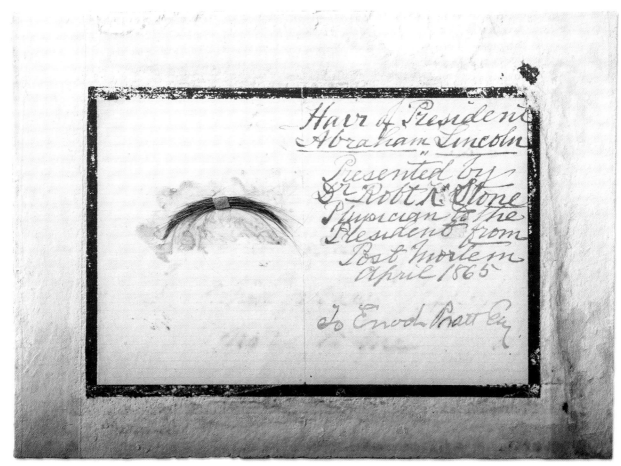

ABOVE / *Crowning glory*

The president's family physician, Dr. Robert King Stone, tended Lincoln shortly after he was shot the night of April 14, 1865, in Ford's Theater until his death the next morning. Dr. Stone also was present during Lincoln's autopsy in the White House. The doctor gave this lock of Lincoln's hair taken during the autopsy to Enoch Pratt, a wealthy Maryland philanthropist who admired the president and supported the war effort. *Gettysburg National Military Park, National Park Service*

LEFT / *A nation grieves*

Lincoln was the first U.S. president to be assassinated. A country in shock mourned for months. In tribute to the late president, men in the military wore mourning armbands on their uniforms; women donned mourning jewelry with his portrait. A Philadelphian wore this mourning badge while watching the train bearing Lincoln's body as it passed through the city on its journey to the president's home in Springfield, Illinois. *On loan from the Civil War Museum of Philadelphia*

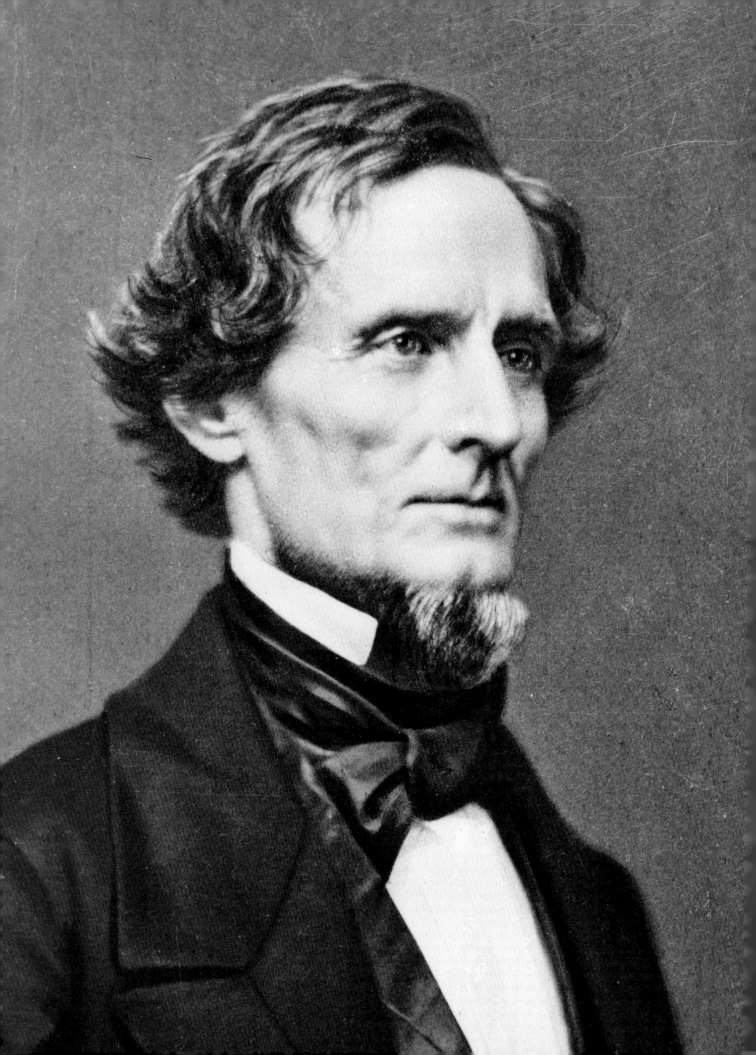

Oh God, spare me this responsibility...I would love to lead the army.

—Jefferson Finis Davis

JEFFERSON FINIS DAVIS
1808–1889
President
Confederate States of America

A frustrated general in civilian clothing, Jefferson Davis longed for a military command once the Southern states began to secede. His countrymen had other ideas.

The first and only president of the Confederacy, Davis had to create a government from the ground up. He had to increase the power of central government to win the war—the very idea opposed by Southerners. A micro-manager, he knocked heads with his cabinet and drove his generals to distraction. Those who criticized him paid for it, yet he stood by those who stood by him.

For the first two years of the war, Davis did a lot with a little. He grappled with less industry and poorly developed rail lines and roads—succeeding anyway. His fortunes changed with defeats at Gettysburg and Vicksburg in summer 1863. As the Union Army's grip tightened, Southerners suffered poverty. Trying to keep the Confederacy alive, Davis remained distant from the people's plight and his popularity sank.

Davis fled as Grant closed in on Richmond in 1865. Less than 48 hours later, Lincoln walked into Davis' office and sat at his desk. One month later, Davis dissolved the Confederate government and went into hiding. Captured, he spent two years in prison. Yet Davis' post-war writings re-casting the Confederate cause as a noble effort to protect "states' rights" boosted his reputation; his funeral was one of the best attended of the South's leaders.

JEFFERSON FINIS DAVIS
1808–1889

Born
• Christian County, Kentucky

Claim to fame
• President of the Confederacy, 1861–1865
• U.S. Senator and Congressman
• U.S. Secretary of War

Education
• Transylvania University
• Jefferson College
• U.S. Military Academy at West Point (23/33 in his class)

Nicknames
• Gamecock of the South (pre-war), One-eyed Jeff, Massa Jeff

Family
• First wife, Sarah Knox Taylor (daughter of famed general and U.S. President Zachary Taylor), died from malaria 3 months after she married Davis
• Second wife, Varina Howell
• Six children: four sons, two daughters (three children survived to adulthood)
• Son Joseph broke his neck and died from a fall off of the balcony at the Confederate executive mansion on April 30, 1864
• Last child, Varina Anne Davis ("Winnie"), became known as "Daughter of the Confederacy;" her image circulated throughout the South

Pets
• Pre-war: Japanese spaniel—a gift of President Franklin Pierce when Davis served as his Secretary of War—that was so small it fit into Davis' pocket
• Post-war: Traveler the dog (favorite)—when Traveler died, Davis wept tears that fell on the dog's body; had a funeral for him and buried him in the yard of his home, Beauvoir

Personal characteristics
• About 6 feet 3 inches tall; "piercing" blue eyes
• Poor health most of his life: malaria; wounds from Mexican War; chronic eye infection so he couldn't tolerate bright light; trigeminal neuralgia, a condition characterized by erratic, shooting pain in the face

Personal trivia
• Named after Thomas Jefferson
• First wife's father didn't like him because he didn't want his daughter to have a military life; consented to wedding only when Davis resigned from the Army
• Met his second wife at a Christmas party
• Owned 100 slaves by 1860
• Appointed a regent of the Smithsonian Institution
• Almost expelled his freshman year at West Point for going to Benny Haven's, a local tavern
• Liked working in his rose garden
• According to one study, No. 1 name for white and African-American sons born in Mississippi, 1870–1880 (out of Confederate leaders): Jefferson Davis

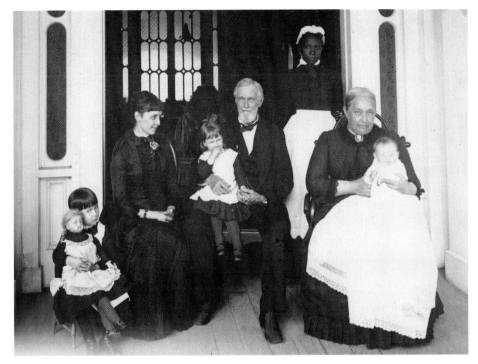

LEFT / Three generations of the Davis family, at his home Beauvoir, c. 1885. Left to right: Granddaughter Varina, daughter Margaret, granddaughter Lucy, Davis, unidentified servant, wife Varina and grandson Jefferson.

BOTTOM RIGHT / Slave quarters at Davis' plantation *Brierfield* near Vicksburg, Mississippi, c. 1857–1860.

RIGHT / Portrait of Varina based on photograph below. *Museum of the Confederacy, Richmond, Virginia*

FAR RIGHT / Davis' wife Varina holding youngest child Varina Anne ("Winnie"), c. 1865. Winnie often traveled with her elderly father on the lecture circuit after the war. *Museum of the Confederacy, Richmond, Virginia*

BELOW / Varina, c. 1860–1870, who served as "First Lady of the Confederacy."

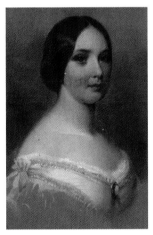

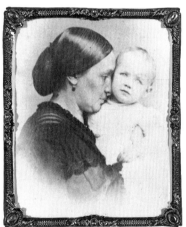

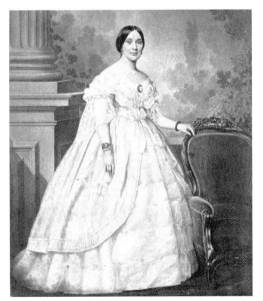

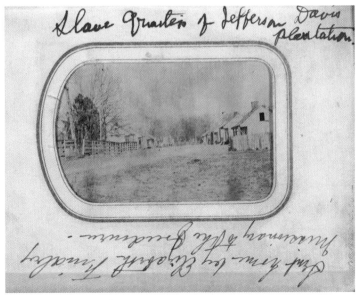

Montgomery, 23d May 1861

Gentlemen,

I receive with sincere pleasure the assurance that the State of Maryland sympathises with the people of these States in their determined vindication of the right of self-Government, and that the people of Maryland "are enlisted with their whole hearts on the side of reconciliation and peace". The people of these Confederate States, notwithstanding their separation from their late sister, have not ceased to feel a deep solicitude in her welfare, and to hope that, at no distant day, a State whose people, habits and institutions are so closely related and assimilated with theirs, will seek to unite her fate and fortunes with those of this Confederacy.

The Government of the Confederate States receive with respect the suggestion of the State of Maryland that there should be "a general cessation of hostilities now impending, until the meeting of the Congress in July next, in order that said body may, if possible, arrange for an adjustment of existing troubles by means of negociation rather than the sword", but is at a loss how to reply without a repetition of the language it has used on every possible occasion that has presented itself, since the establishment of its independence. In deference to the State of Maryland, however, it again asserts, in the most emphatic terms, that its sincere and earnest desire is for peace: that whilst the Government would readily entertain any proposition from the Government of the United States tending to a peaceful solution of the pending difficulties, the recent attempts of this Government to enter into negociations with that of the United States, were attended with results which forbid any renewal of proposals from it to that Government.

If any further assurance of the desire of this Government for peace were necessary, it would be sufficient to observe that, being formed of a Confederation of Sovereign States, each

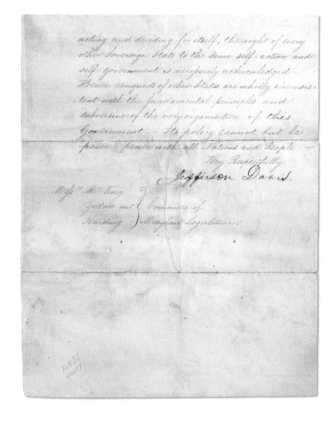

acting and deciding for itself, the right of every other Sovereign State to the same self-action and self-government is necessarily acknowledged. Hence conquests of other States are wholly inconsistent with the fundamental principles and subversive of the very organisation of this Government. Its policy cannot but be peace: peace with all Nations and People.

Very Respectfully
Jefferson Davis.

Messrs. McKaig
Yellott and } Committee of
Harding } Maryland Legislature

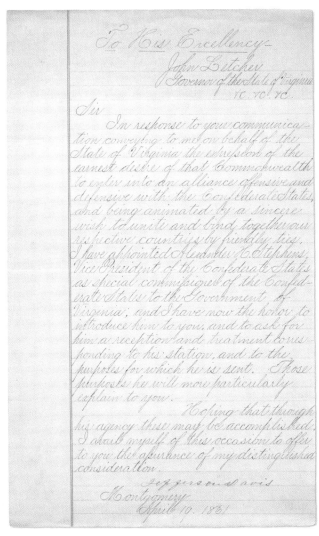

GLC 02285

ABOVE / *Making his case*

Davis was sworn in as the Confederacy's first president
February 18, 1861, several weeks before Lincoln took his
inaugural oath. One of Davis's first responsibilities was
convincing states that had seceded from the Union to join
the Confederacy. In this April 19, 1861, letter written
two days after Virginia's secession, Davis urges Virginia
Governor John Letcher to form such an alliance and
introduces Vice President Alexander H. Stephens as his
emissary to negotiate the association. *On loan from the
Gilder Lehrman Institute of American History*

LEFT / *Difference of opinion*

Davis struggled to give states that seceded from the
Union solid reasons and plans for moving forward and
joining what he called in this May 25, 1861, letter to
the Maryland state legislature the "Confederacy of
Sovereign States." Members of the Maryland legislature
had appealed to Davis to find a peaceful solution to the
differences between North and South; Davis declined.
Maryland remained in the Union but its conflicted citizens
fought in both the Union and Confederate armies. *On loan
from the Gilder Lehrman Institute of American History*

RICHMOND ENQUIRER.

EXTRA.

PRESIDENT JEFFERSON DAVIS'S INAUGURAL ADDRESS.
Delivered in Richmond, February 22, 1862.

Fellow-Citizens: On this, the birth-day of the man most identified with the establishment of American independence, and beneath the monument erected to commemorate his heroic virtues and those of his compatriots, we have assembled to usher into existence the permanent Government of the Confederate States. Through this instrumentality, under the favor of Divine Providence, we hope to perpetuate the principles of our Revolution my fathers. The day, the memory and the purpose seem fitly associated.

It is with mingled feelings of humility and pride that I appear to take, in the presence of the people and before high Heaven, the oath prescribed as a qualification for the exalted station to which the unanimous voice of the people has called me. Deeply sensible of all that is implied by this manifestation of the people's confidence, I am yet more profoundly impressed by the vast responsibility of the office, and humbly feel my own unworthiness.

In return for their kindness, I can only offer assurances of the gratitude with which it is received, and can but pledge a zealous devotion of every faculty to the service of those who have chosen me as their Chief Magistrate.

When a long course of class legislation, directed not to the general welfare, but to the aggrandizement of the Northern section of the Union, culminated in a warfare on the domestic institutions of the Southern States—when the dogmas of a sectional party, substituted for the provisions of the constitutional compact, threatened to destroy the sovereign rights of the States, six of those States, withdrawing from the Union, confederated together, to exercise the right and perform the duty of instituting a government which would better secure the liberties, for the preservation of which that Union was established.

Whatever of hope some may have entertained that a returning sense of justice would remove the danger with which our rights were threatened, and render it possible to preserve the Union of the Constitution, must have been dispelled by the malignity and barbarity of the Northern States in the prosecution of the existing war. The confidence of the most hopeful among us must have been destroyed by the disregard they have recently exhibited for all the time-honored bulwarks of civil and religious liberty. Bastiles filled with prisoners, arrested without civil process, or indictment duly found; the writ of habeas corpus suspended by Executive mandate; a State Legislature controlled by the imprisonment of members whom avowed principles suggested to the Federal Executive that there might be another added to the list of seceded States; elections held under threats of a military power; civil officers, peaceful citizens, and gentle women incarcerated for opinion's sake, proclaimed the incapacity of our late associates to administer a government as free, liberal and humane as that established for our common use.

For proof of the sincerity of our purpose to maintain our ancient institutions, we may point to the Constitution of the Confederacy and the laws enacted under it, as well as to the fact that through all the necessities of an unequal struggle, there has been no act on our part to impair personal liberty or the freedom of speech, of thought or of the press. The Courts have been open; the judicial functions fully executed, and every right of the peaceful citizen maintained as securely as if a war of invasion had not disturbed the land.

The people of the States now confederated became convinced that the Government of the United States had fallen into the hands of a Sectional Majority who would pervert that most sacred of all trusts to the destruction of the rights which it was pledged to protect. They believed that to remain longer in the Union would subject them to a continuance of a disparaging discrimination, submission to which would be inconsistent with their welfare, and intolerable to a proud people. They therefore determined to sever its bonds, and establish a new Confederacy for themselves. [Cheers.]

The experiment instituted by our revolutionary fathers of a voluntary union of sovereign States for purposes specified in a solemn compact, had been perverted by those, who feeling power and forgetting right, were determined to respect no law but their own will. The Government had ceased to answer the ends for which it was ordained, and established. To save ourselves from a revolution, which, in its silent but rapid progress was about to place us under the despotism of numbers, and to preserve in spirit as well as in form, a system of government, we believed to be peculiarly fitted to our condition and full of promise for mankind, we determined to make a new association composed of States homogeneous in interest, in policy and in feeling. [Cheers.]

True to our traditions of peace and our love of justice, we sent commissioners to the United States to propose a fair and amicable settlement of all questions of public debt or property which might be in dispute. But the Government at Washington denying our right to self government, refused even to listen to any proposals for a peaceful separation.—Nothing was then left us but to prepare for war. [Cheers.]

The first year in our history has been the most eventful in the annals of this Continent. A new government has been established, and its machinery put in operation, over an area exceeding 700,000 square miles. The great principles upon which we have been willing to hazard every thing that is dear to man, have made conquests for us which could never have been achieved by the sword. Our Confederacy has grown from six to thirteen States; and Maryland, already united to us by hallowed memories, and material interests, will, I believe, when able to speak with unstifled voice, connect her destiny with the South. [Great applause.] Our people have rallied with unexampled unanimity to the support of the great principles of Constitutional government, with firm resolve to perpetuate by arms the rights which they could not peacefully secure. A million of men, it is estimated, are now standing in hostile array, and waging war along a frontier of thousands of miles; battles have been fought; sieges have been conducted, and although the contest is not ended, and the tide for the moment is against us, the final result in our favor is not doubtful.

The period is near at hand when our foes must sink under the immense load of debt which they have incurred; a debt which in their effort to subjugate us has already attained such fearful dimensions as will subject them to burthens which must continue to oppress them for generations to come.

We too have had our trials and difficulties. That we are to escape them in future is not to be hoped. It was to be expected when we entered upon this war that it would expose our people to sacrifices and cost them much, both of money and blood. But we knew the value of the object for which we struggled, and understood the nature of the war in which we were engaged. Nothing could be so bad as failure, and any sacrifice would be cheap as the price of success in such a contest. [Cheers.]

But the picture has its lights as well as its shadows. This great strife has awakened in the people the highest emotions and qualities of the human soul. It is cultivating feelings of patriotism, virtue and courage. Instances of self-sacrifice, and of generous devotion to the noble cause for which we are contending, are rife throughout the land. Never has a people evinced a more determined spirit than that now animating men, women and children in every part of our country. Upon the first call the men fly to arms; and wives and mothers send their husbands and sons to battle, without a murmur of regret.

It was, perhaps, in the ordination of Providence that we were to be taught the value of our liberties by the price which we pay for them.

The recollections of this great contest with all its common traditions of glory, of sacrifice, and of blood will be the bond of harmony and enduring affection amongst the people, producing unity in policy, fraternity in sentiment and joint effort in war.

Nor have the material sacrifices of the past year been made without some corresponding benefits. If the acquiescence of foreign nations in a pretended blockade has deprived us of our commerce with them, it is fast making us a self supporting and an independent people. The blockade, if effectual and permanent, could only serve to divert our industry from the production of articles for export, and employ it in supplying commodities for domestic use.

It is a satisfaction that we have maintained the war by our unaided exertions. We have neither asked nor received assistance from any quarter. Yet the interest involved is not wholly our own. The world at large is concerned in opening our markets to its commerce. When the independence of the Confederate States is recognized by the nations of the earth, and we are free to follow our interests and inclinations by cultivating foreign trade, the Southern States will offer to manufacturing nations the most favorable markets which ever invited their commerce. Cotton, sugar, rice, tobacco, provisions, timber and naval stores will furnish attractive exchanges. Nor would the constancy of these supplies be likely to be disturbed by war. Our Confederate strength will be too great to tempt aggression, and never was there a people whose interests and principles committed them so fully to a peaceful policy as those of the Confederate States. By the character of their productions they are too deeply interested in foreign commerce wantonly to disturb it. War of conquest they cannot wage, because the Constitution of their Confederacy admits of no coerced association. Civil war there cannot be between States held together by their volition only. This rule of voluntary association, which cannot fail to be conservative, by securing just and impartial government at home, does not diminish the security of the obligations by which the Confederate States may be bound to foreign nations. In proof of this it is to be remembered, that at the first moment of asserting their right of secession, these States proposed a settlement on the basis of a common liability for the obligations of the General Government.

Fellow-Citizens: After the struggle of ages had consecrated the right of the Englishman to Constitutional Representative Government, our colonial ancestors were forced to vindicate that birthright by an appeal to arms. Success crowned their efforts, and they provided for their posterity, a peaceful remedy against future aggression.

The tyranny of an unbridled majority, the most odious, and least responsible form of despotism has denied us both the right and the remedy. Therefore, we are in arms to renew such sacrifices as our fathers made to the holy cause of Constitutional liberty. At the darkest hour of our struggle the Provisional gives place to the Permanent Government. After a series of successes and victories, which covered our arms with glory, we have recently met with serious disasters. But in the heart of a people resolved to be free, these disasters tend but to stimulate to increased resistance.

To show ourselves worthy of the inheritance bequeathed to us by the patriots of the Revolution, we must emulate that heroic devotion which made reverse to them but the crucible in which their patriotism was refined. [Applause.]

With confidence in the wisdom and virtue of those who will share with me the responsibility, and aid me in the conduct of public affairs; securely relying on the patriotism and courage of the people, of which the present war is furnished so many examples, I deeply feel the weight of the responsibilities I now, with unaffected diffidence, am about to assume; and fully realizing the inadequacy of human power to guide and to sustain, my hope is reverently fixed on Him whose favor is ever vouchsafed to the cause which is just. With humble gratitude and adoration, acknowledging the Providence which has so visibly protected the Confederacy during its brief, but eventful career, to Thee, Oh God! I trustingly commit myself, and prayerfully invoke Thy blessing on my country and its cause.

[Continued and enthusiastic cheering.]

Evacuation of Nashville.

AUGUSTA, Feb. 22—Private dispatches received here from Chattanooga state that Federal gunboats reached Nashville on Thursday.

SAVANNAH, Feb. 22—General Walker has received dispatches which state the Confederates have evacuated Nashville.

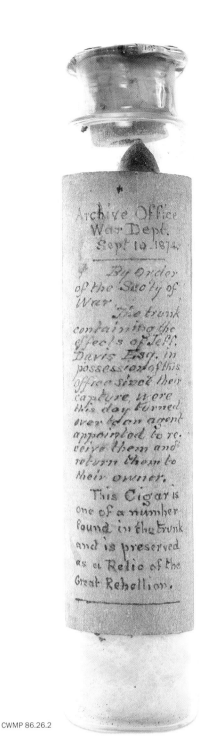

Archive Office
War Dept.
Sept 10. 1874.

By Order
of the Sec'ty of
War. The trunk
containing the
effects of Jeff.
Davis Esq. in
possession of this
office since their
capture, were
this day turned
over to an agent
appointed to re-
ceive them and
return them to
their owner.

This Cigar is
one of a number
found in the trunk
and is preserved
as a Relic of the
Great Rebellion.

CWMP 86.26.2

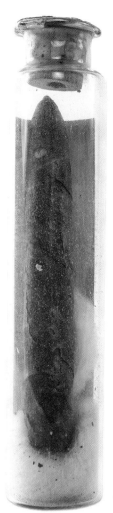

CWMP 86.26.2, Rear Detail

LEFT & ABOVE / *Rebellion relic*

Captured trying to escape at the end of the war while wearing his wife's cloak—which he had grabbed mistakenly in the dark as Union soldiers approached to arrest him— Davis had several cigars stowed in a trunk with his effects. The soldiers seized the trunk; Davis was charged with treason. In 1874, Davis was released after serving two years in prison. The War Department returned his trunk— minus this cigar, which was "preserved as a relic of the Great Rebellion." *On loan from the Civil War Museum of Philadelphia*

FAR LEFT / *State of independence*

Davis served as Provisional President of the Confederate States of America for one year before he was inaugurated as the Confederacy's president on February 22, 1862, and gave this speech. In it, he drew parallels between the South's cause and that of colonial Americans fighting for independence in the Revolutionary War, saying "we are in arms to renew such sacrifices as our fathers made to the holy cause of constitutional liberty." *On loan from the Gilder Lehrman Institute of American History*

CWMP 86.39.1

ABOVE / *Official piracy*
To divert ships in the Union Navy from their blockade of
Southern ports, Davis authorized the outfitting of private
merchant vessels with arms to capture other unarmed
merchant vessels and seize, then auction off their goods.
Signed by Davis and Confederate Secretary of State
Robert Toombs, this 1861 commission of the schooner
Petrel establishes her and her captain, William Perry,
as part of the privateer effort. *On loan from the Civil War
Museum of Philadelphia*

RIGHT / *Elegance at home*
This silk and wool civilian dressing gown belonged to Davis
and was stored in a trunk when Union soldiers captured
him at the war's end. He never wore it in captivity. After
the war, Davis strolled the grounds of his Mississippi home
Beauvoir with grain stuffed into the pockets of a dressing
gown to feed the peafowls on his property. *On loan from
the Civil War Museum of Philadelphia*

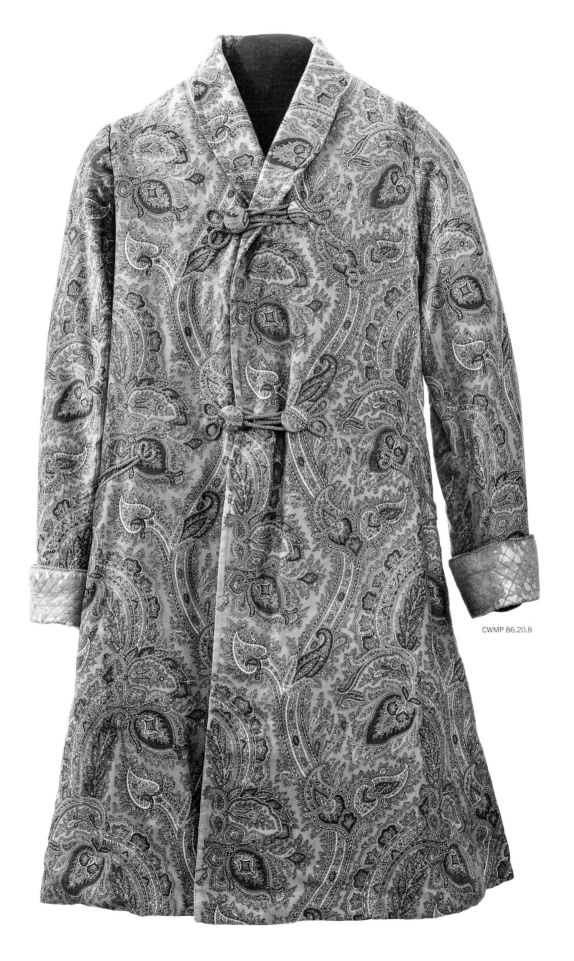

CWMP 86.20.8

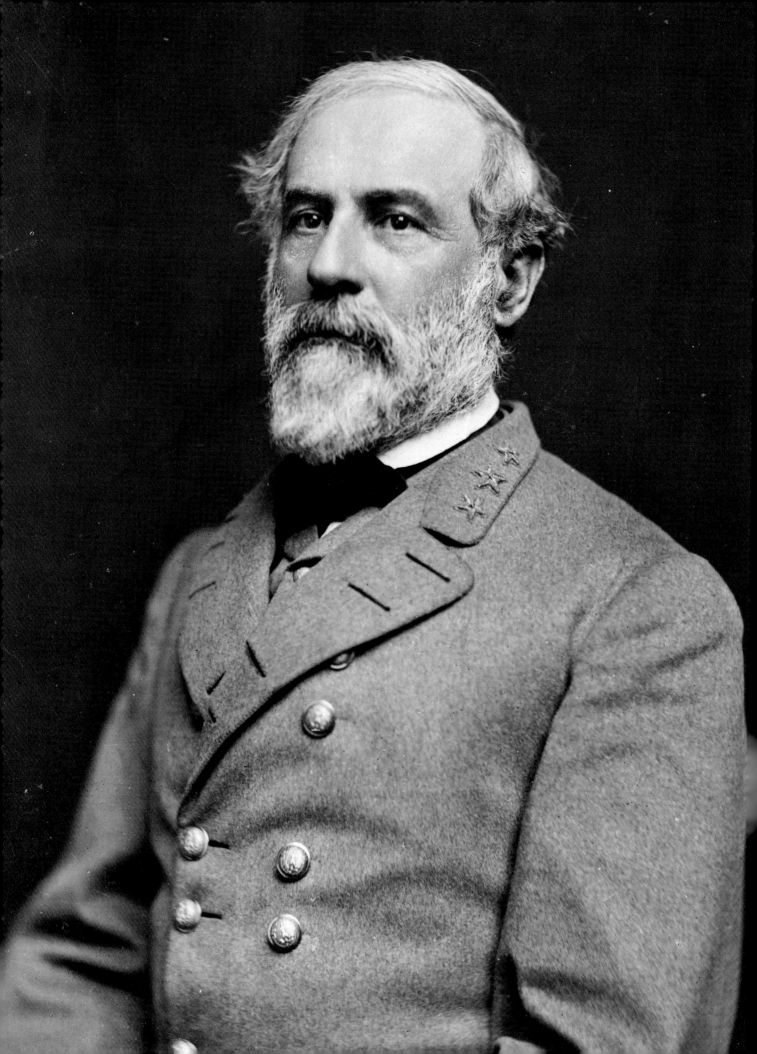

The war will last at least four years. Northern politicians will not appreciate the determination and pluck of the South, and Southern politicians do not appreciate the numbers, resources and patient perseverance of the North. Both sides forget that we are all Americans.

—Robert Edward Lee

ROBERT EDWARD LEE
1807–1870
Confederate Army General

One of the most revered generals in U.S. history, Robert E. Lee came to the military and national fame with a long pedigree. He was related to two signers of the Declaration of Independence and Revolutionary War General "Light-horse Harry" Lee.

The Virginian was Lincoln's first choice to lead the Union Army. Lee turned down the president—and the career opportunity of a lifetime. Although several Southern-born officers stayed with the Union, Lee believed in a slaveholding republic. He also could not wage war against family in his own backyard. Home was home; honor was honor.

Every commander Lincoln initially threw at him, Lee hurled back in defeat. His record won approval for a bold plan to invade the North. When Lee's army neared Gettysburg, his confidence in its invincibility was never higher. It also proved his undoing. He pushed hard all three days of the battle, sure his men would prevail. When they did not, Lee said to them, "It's all my fault."

Lee was never the same. He kept the spirit of the army alive and tried to dodge the pummeling of Grant's forces—to no avail. A year and a half after Gettysburg, Lee gave way, saying to an aide: "There is nothing left for me to do but to see Grant, and I would rather die a thousand deaths." In his farewell address to his troops, Lee blamed the war's outcome on attrition, saying he was "compelled to yield to overwhelming numbers and resources."

ROBERT EDWARD LEE
1807–1870

Born
- Stratford Hall, Virginia

Claim to fame
- Led U.S. forces at John Brown's raid at Harper's Ferry
- General-in-Chief, Confederate Armies
- Superintendent, U.S. Military Academy at West Point
- President, Washington College (now Washington and Lee University)

Education
- U.S. Military Academy at West Point (2/46 in his class)

Nicknames
- Ace of Spades, King of Spades, Spades Lee, The Marble Man, Granny Lee/Evacuating Lee (1861), Marse Robert, The Tycoon (his staff), Uncle Robert (his soldiers)

Horse(s) in Civil War
- Traveller, Lucy Long (gift from Jeb Stuart), Ajax, Roan, Richmond

Family
- Wife, Mary Anna Randolph Custis
- Seven children: four daughters, three sons
- His wife was related to George Washington's family

Personal characteristics
- About 5 feet, 11 inches tall, 175 lbs.
- Small feet

Favorite foods
- Best bedtime snack: fresh buttermilk; got sick at siege of Petersburg when he drank a tainted supply

Favorite subject to study
- Astronomy

Pets
- Daughter had a pet squirrel called Custis Morgan (named partly for her brother; partly for cavalry commander John Hunt Morgan); the squirrel bit Mrs. Lee's doctor
- Pet hen reportedly accompanied him during the war

Personal trivia
- When his children were young, loved to kick off his slippers, rest his feet in their laps and tell them they would only hear a bedtime story if they tickled him
- Once as a young married man, pretended to be single to get pretty girls' attention at a party
- Let his kids jump in bed with him in the morning for a snuggle
- Rented a house in Baltimore with his wife and young family in 1849— said it was so small "hardly big enough to swing a cat in"
- Didn't trust doctors or medicine; the best prescription, he told a friend: "Avoid all medicines"
- Bought leeches and lavender from an Alexandria apothecary (which still stands) to treat his headaches; bought his housepaint there, too
- When suitors called on his daughters, Lee put them in the parlor and let them visit until 10 p.m. If the caller was still there at curfew time, Lee went into the parlor and closed the shutters. If that didn't work, he sat down to talk to the young man to scare him off.

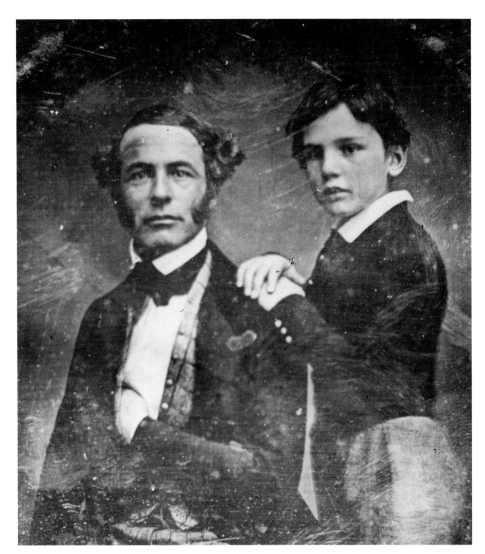

LEFT / Lee, 38, with son William Henry Fitzhugh ("Rooney"), 8, c. 1845. Rooney and two other sons later served with their father during the war. *Virginia Historical Society*

RIGHT / Lee's wife, Mary Anna Custis, with youngest son Robert E. Lee Jr. Well educated and an early anti-slavery activist, Mary—also known as Molly—had her choice of prominent suitors, including Sam Houston. Instead, she chose to marry childhood playmate and distant cousin, Robert E. Lee. *Virginia Historical Society*

Arlington Washington City P. O.
1. April 1861

Lt Col E. D. Townsend
Asst Adjt Genl Hd Qrs: of the Army
 Washington City D. C.

 Colonel
 I have the honour to report that having
in Compliance with S. Orders No. 16 from the Hd Qrs: of
the Dept: of Texas, reported in person to the Genl in Chief
I await his instructions —
 My address is "Arlington Washington City P. O"
 I am very respt your Obt Servt
 R E Lee
 Col 1st Cavy

as you think Convenient.

Establish your Head Quarters as necessary. Establish Camps of instruction, and have your troops instructed in the use of their different arms. Make the necessary arrangements for their support. No bacon is to be had in Virginia. Consult with merchants in Alexandria as to the feasibility of obtaining bacon from Ohio, or Kentucky, if this is not practicable, beef & mutton must be your meat ration; the Valley of Virginia nice naturally suggest itself to you as the point, from which this part of the ration can be obtained.

Let it be known that you intend to make no attack; but, invasion of our soil, will be considered as an act of war.

Very few Officers of experience have as yet reported, as soon as possible some will be sent to you.

In reference to the Regiment to be raised by Mr. Funsten, I will state, that, in Conformity to an Ordinance of Convention, volunteers are accepted by Companies, when organized into Regiments, the Field Officers are appointed, by the Governor & Council. It is not believed now, that the enemy will attack you, should he do

GLC 03874

ABOVE / *Laying the groundwork*

Written just two days after Lee accepts command of the Virginia State Militia, this letter to the Confederate commander first charged with defenses along the Potomac River reveals Lee's early leadership style. No detail escapes him. Lee also directs the recipient on handling impending hostilities: "Let it be known that you intend to make no attack; but, invasion of our soil, will be considered as an act of war." *On loan from the Gilder Lehrman Institute of American History*

LEFT / *Resignation*

A U.S. Army officer for more than 30 years, Lee was colonel of the 1st U.S. Cavalry when he wrote this April 1, 1861, letter. Little more than two weeks later, Lincoln offered him command of the Union Army. Lee declined, resigning from the U.S. Army three days later, writing to a sister who supported the Union, "I have not been able to make up my mind to raise my hand against my relatives, my children, my home." *On loan from the Gilder Lehrman Institute of American History*

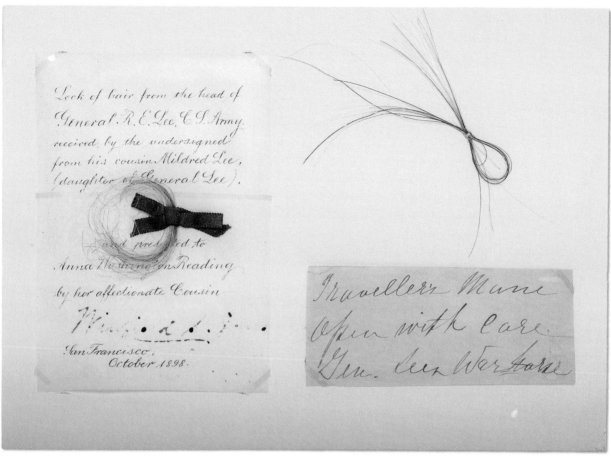

ARHO 3564

ABOVE / *Lifelong companions*
Locks of Lee's hair and his horse Traveller's mane.
After the war when Lee became president of Washington
College in Lexington, Virginia, he took Traveller on rides
in the mountains to take breaks from the stress of his
college post. Traveller outlived his owner, but not for long:
He succumbed to tetanus after stepping on a rusty nail.
He is buried within yards of his master's resting place, just
outside the chapel on the campus of what today is known
as Washington and Lee University. *On loan from Arlington
House, The Robert E. Lee Memorial, National Park Service*

RIGHT / *Comrades in arms*
The only known wartime photograph of Lee on his favorite
horse, Traveller, taken during the siege of Petersburg
toward the end of the war. Although Lee owned and rode
other horses during the war—including Lucy Long, Ajax
and the Roan—he and Traveller remained inseparable.
*On loan from Arlington House, The Robert E. Lee Memorial,
National Park Service*

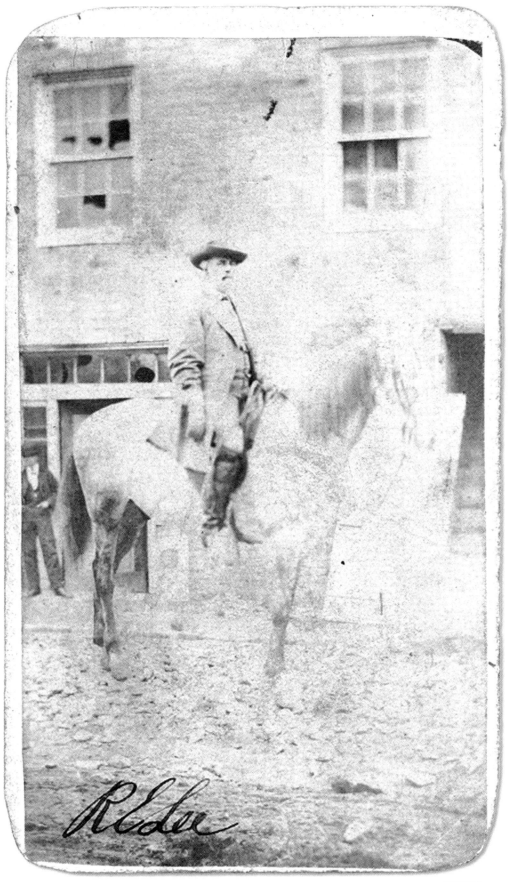

R E Lee

RIGHT / *Every inch the general*
Watercolor engraving of Lee in uniform with the general's
signature, 1866. *Gettysburg National Military Park,
National Park Service*

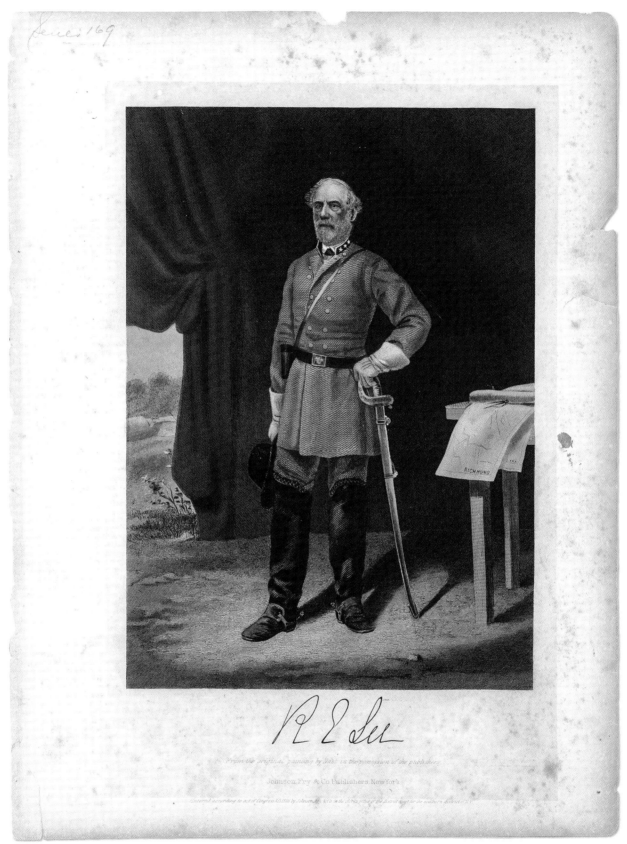

R E Lee

From the original painting by Nagel in the possession of the publishers.

Johnson, Fry & Co Publishers, New York.

Entered according to act of Congress AD 1865 by Johnson, Fry & Co in the clerks office of the District court for the southern district of N.Y.

HEAD-QUARTERS ARMY N. VA.,
NEAR FREDERICK TOWN, 8th September, 1862.

TO THE PEOPLE OF MARLAND:

It is right that you should know the purpose that has brought the Army under my command within the limits of your State, so far as that purpose concerns yourselves.

The People of the Confederate States have long watched with the deepest sympathy the wrongs and outrages that have been inflicted upon the citizens of a Commonwealth, allied to the States of the South by the strongest social, political and commercial ties.

They have seen with profound indignation their sister State deprived of every right, and reduced to the condition of a conquered Province.

Under the pretence of supporting the Constitution, but in violation of its most valuable provisions, your citizens have been arrested and imprisoned upon no charge, and contrary to all forms of law; the faithful and manly protest against this outrage made by the venerable and illustrious Marylanders to whom in better days, no citizen appealed for right in vain, was treated with scorn and contempt; the government of your chief City has been usurped by armed strangers; your Legislature has been dissolved by the unlawful arrest of its members; freedom of the press and of speech has been suppressed; words have been declared offences by an arbitrary decree of the Federal Executive, and citizens ordered to be tried by a military commission for what they may dare to speak.

Believing that the People of Maryland possessed a spirit too lofty to submit to such a government, the people of the South have long wished to aid you in throwing off this foreign yoke, to enable you again to enjoy the inalienable rights of freemen, and restore independence and sovereignty to your State.

In obedience to this wish, our Army has come among you, and is prepared to assist you with the power of its arms in regaining the rights of which you have been despoiled.

This, Citizens of Maryland, is our mission, so far as you are concerned.

No constraint upon your free will is intended, no intimidation will be allowed.

Within the limits of this Army at least, Marylanders shall once more enjoy their ancient freedom of thought and speech.

We know no enemies among you, and will protect all of every opinion.

It is for you to decide your destiny, freely and without constraint.

This army will respect your choice whatever it may be, and while the Southern people will rejoice to welcome you to your natural position among them, they will only welcome you when you come of your own free will.

R. E. LEE, General Commanding.

GLC 07195

ABOVE / *Offer of liberty*

In his first attempt to invade the North, Lee wrote directly to the people of Maryland in fall 1862, urging them to join forces with the Confederacy, saying, "the people of the South have long wished to aid you in throwing off this foreign yoke [the Union] to enable you again to enjoy the inalienable rights of freemen." Nine days after this broadside was published, Union and Confederate forces clashed at Antietam. *On loan from the Gilder Lehrman Institute of American History*

RIGHT / *Advice ignored*

Shortly after Lee's defeat to Grant at Cold Harbor, Lee wrote his commander-in-chief on June 9, 1864, recommending that Davis send Confederate commander Kirby Smith to Georgia to shore up its defense—advice that Davis ignored. As a result, Sherman captured Atlanta—a success that bolstered Lincoln's stock with citizens and helped him win the 1864 election. *On loan from the Gilder Lehrman Institute of American History*

induces one to believe that he is awaiting the effect of
movements in some other quarter to make us change our
position, and renders the suggestion I make with reference to
the intention and destination of Gen Sheridan more probable.
It was stated by a prisoner captured yesterday belonging
to Gen Sheridan's Command, that they had heard that Gen
Morgan was in Pa, and that they were going in pursuit
I mention this improbable story as you may know wheth
er there is any truth in the statement with reference to
Gen Morgan. A negro servant belonging to our army
who had been captured by the enemy, made his escape
from Gen Sheridan yesterday at 11 AM near Mango-
hick Church, and was under the impression that
they would encamp that night at Bowling Green.
Three prisoners brought in to Gen Hampton confirm
in part the statement of the servant.
An extract from the Philadelphia Inquirer published in
our papers reports that the army of the N West under Gen
Pope was on its way to reinforce that of the Potomac, and
a gentleman from the Valley says that a force of two
or three thousand men, believed to be under Gen Pope,
was moving to join Gen Hunter, and should have
reached Staunton by this time. There may be there
fore some probability in the story. I do not know
whence reinforcements can be drawn to our ar

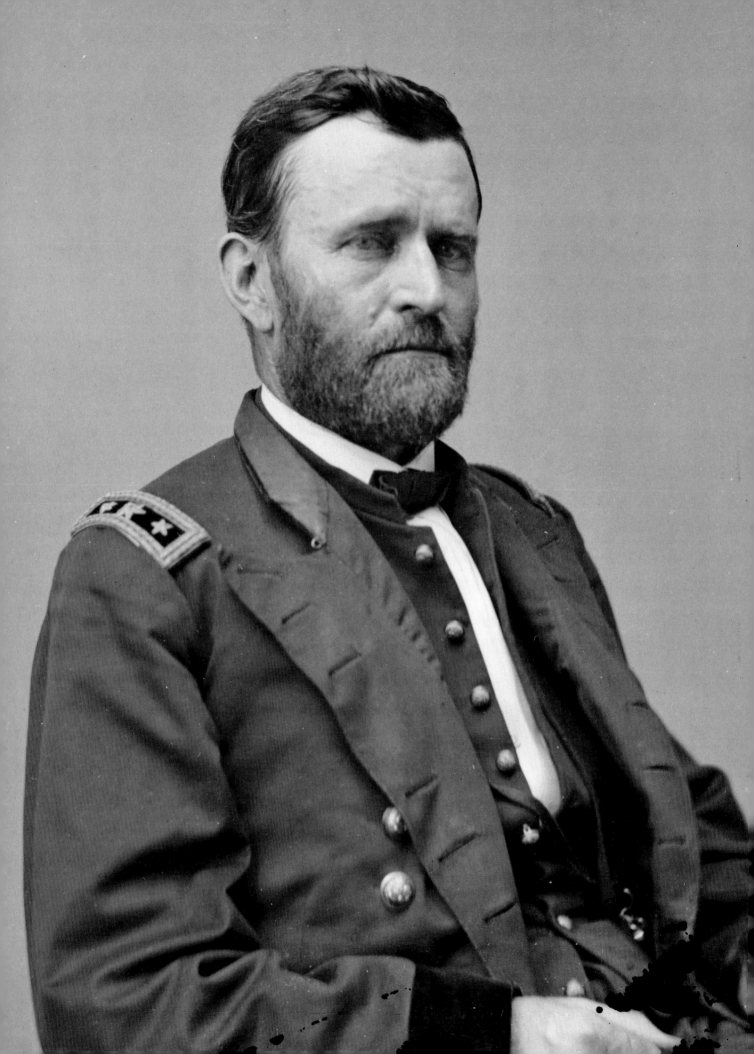

I am heartily tired of hearing about what Lee is going to do. Some of you always seem to think he is suddenly going to turn a double somersault, and land in our rear and on both of our flanks at the same time. Try to think what we are going to do instead.

—Ulysses Grant

ULYSSES GRANT
1822–1885
Union Army General

A West Point graduate who had left the army and fell short at every other job, Ulysses Grant seemed least likely to crush the Confederate rebellion. Yet once he took the initiative, he never let go—constantly pursuing and attacking the enemy.

His relentlessness led to victory—but his reviews weren't always good. After Shiloh, public opinion about Grant sank when news that lack of preparation and alleged drunkenness led to high casualties. Many called for his removal. Lincoln refused, saying, "I can't spare this man. He fights."

Grant knew winning the war was about one thing: the defeat and destruction of Lee's Confederate Army of Northern Virginia. Impressed with "the quiet little man" who kept enemy troops off balance, Lincoln promoted Grant to General-in-Chief of all Union forces, as well as lieutenant general—a rank not held by an American officer since George Washington. Although the war had raged for three years by the time Lincoln gave Grant the top post, it ended little more than one year later.

He fought fiercely yet won praise for how he handled the Confederates' surrender: he allowed them to return home and to keep their personal sidearms, horses and baggage. He gave rations to starving Confederate soldiers. As Lee left the surrender meeting, Union soldiers cheered. Grant rebuked them, saying the former enemy soldiers "are our countrymen again."

ULYSSES GRANT
1822–1885

Born
• Point Pleasant, Ohio

Claim to fame
• Union General-in-Chief, won the Civil War
• 18th President of the United States, 1869–1877

Education
• U.S. Military Academy at West Point (21/39 in his class)

Nicknames
• Lyss/Lyssus (boyhood), Buck (pre-war), Company Grant (West Point),
 The Quiet Man, Hero of Appomattox, Sam, Butcher, Uncle Sam,
 United States/US Grant, Unconditional Surrender, Old Unconditional,
 Dudy (Mrs. Grant's pet name for him), Great Hammerer

Horse(s)
• Cincinnati (his favorite), Methuselah (at beginning of war),
 Rondy (first rode into battle), Fox, Jack, Jeff Davis and Kangaroo

Family
• Wife, Julia Boggs Dent, daughter of a prominent Missouri plantation
 and slave owner
• Four children: three boys, one girl

Pet
• Faithful (Newfoundland dog), while U.S. President

Personal characteristics
• Light brown hair and beard, blue eyes
• Suffered migraine headaches
• Tone deaf
• Part Scottish. Grant clan motto: "Stand fast." Carried a piece
 of the Grant tartan with him during the war.

Favorite foods
• Couldn't stand the sight of blood; cooks charred his red meat
 until completely black
• Favorite breakfast: coffee and sliced cucumbers in vinegar
• Claimed he didn't like to eat anything that walked on two legs

Personal trivia
• Birth name is Hiram Ulysses Grant. Changed his name when Ohio
 congressman who recommended his appointment to West Point
 nominated him incorrectly as "Ulysses S. Grant." The "S" didn't stand
 for anything.
• Owned a slave. Rather than sell him for much-needed cash,
 freed the slave for nothing
• Studied under renowned Hudson River School artist Robert Walter
 Weir, professor of drawing at West Point
• Confederate General James Longstreet went to his wedding;
 Mrs. Grant was his fourth cousin
• Disliked music. "I know only two tunes: one of them is *Yankee
 Doodle*, and the other isn't."
• Outstanding horseman, set a record for the high jump at West Point
• Racked up demerits at West Point for not attending church; got good
 grades in math and geology
• Stood by himself and wept at Lincoln's funeral
• Mark Twain's company published his memoirs

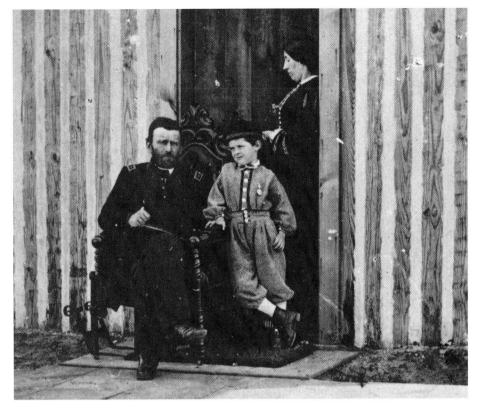

LEFT / Grant with wife Julia and youngest son Jesse at Army headquarters in City Point, Virginia, 1864. His son was named for Grant's father and later joined the Democratic Party in an attempt to run for president.

BOTTOM RIGHT / Grant at his New York cottage three days before his death from throat cancer. For six weeks, he lived there while finishing his memoirs—which provided for his family after he died.

RIGHT / Grant's daughter Nellie holding her niece and his granddaughter, Julia Dent Grant—known as "Princess Cantacuzène" after she married a Russian Imperial Army general.

FAR RIGHT / Jesse, Julia and Nellie.

BELOW / Lithograph of Grant family, left to right: son Frederick, wife Julia, son Jesse, son Ulysses Jr., Grant and Nellie.

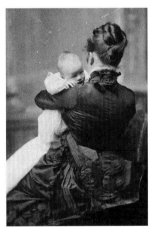

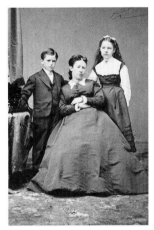

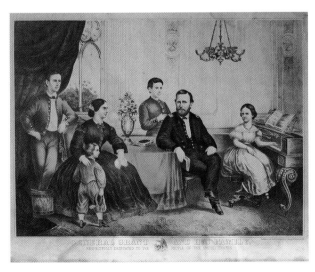

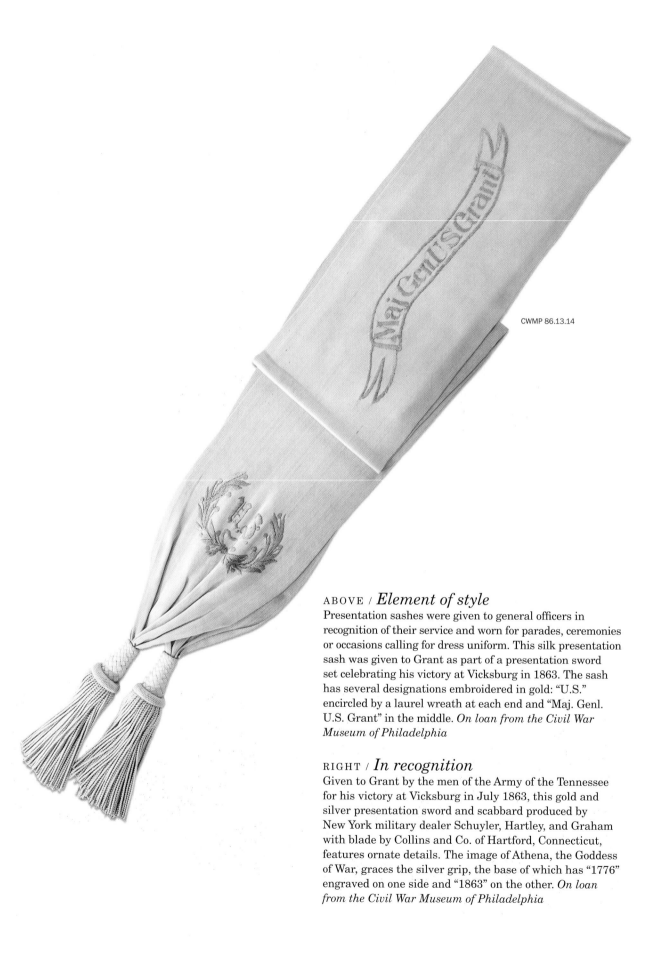

CWMP 86.13.14

ABOVE / *Element of style*
Presentation sashes were given to general officers in recognition of their service and worn for parades, ceremonies or occasions calling for dress uniform. This silk presentation sash was given to Grant as part of a presentation sword set celebrating his victory at Vicksburg in 1863. The sash has several designations embroidered in gold: "U.S." encircled by a laurel wreath at each end and "Maj. Genl. U.S. Grant" in the middle. *On loan from the Civil War Museum of Philadelphia*

RIGHT / *In recognition*
Given to Grant by the men of the Army of the Tennessee for his victory at Vicksburg in July 1863, this gold and silver presentation sword and scabbard produced by New York military dealer Schuyler, Hartley, and Graham with blade by Collins and Co. of Hartford, Connecticut, features ornate details. The image of Athena, the Goddess of War, graces the silver grip, the base of which has "1776" engraved on one side and "1863" on the other. *On loan from the Civil War Museum of Philadelphia*

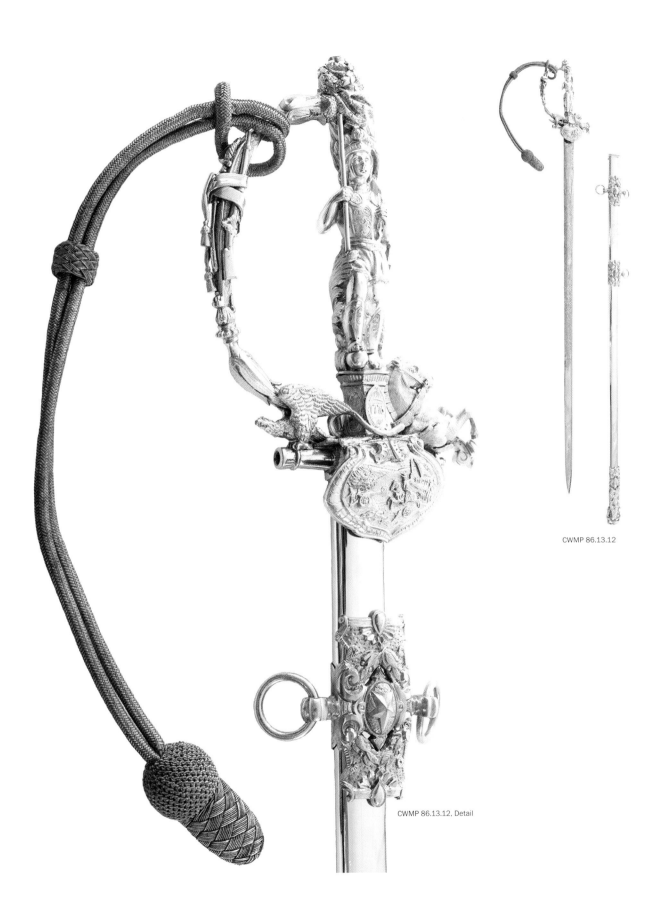

CWMP 86.13.12

CWMP 86.13.12, Detail

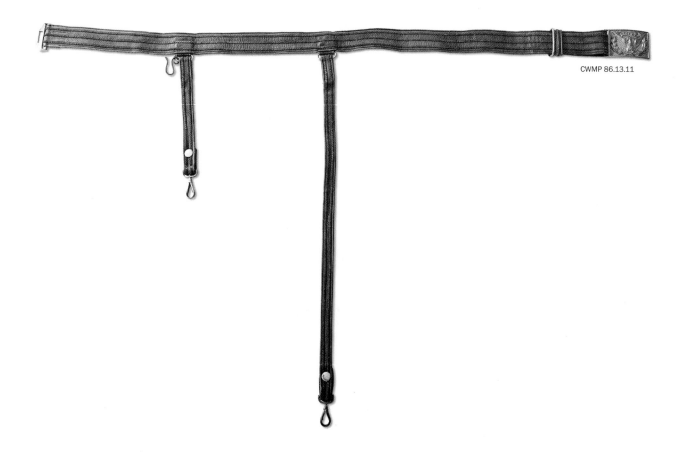

CWMP 86.13.11

One of many

Grant's sword belt features red morocco leather sling straps and two gold bullion stripes. The buckle shows a Federal eagle above a laurel wreath clasping a banner reading "E Pluribus Unum" in its beak. It is part of the presentation set of sash and sword shown on pages 48 and 49, respectively. *On loan from the Civil War Museum of Philadelphia*

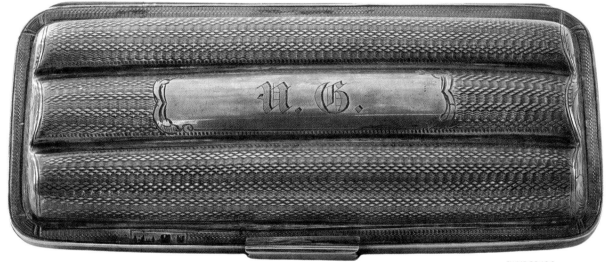

Hard habit to break

Grant's initials—U.G.—are engraved on the top of this silver case, which held six cigars. Grant told a comrade, Horace Porter, that he had been a light smoker before the attack on Fort Donelson in February 1862, but after newspapers printed stories that he smoked cigars during the battle, he received more than 10,000 as gifts. Some accounts reported that he smoked up to 20 cigars a day. Grant died of throat cancer. *On loan from the Civil War Museum of Philadelphia*

ABOVE / *Friends in high places*

Early in the war Grant relied on the patronage of others to secure military roles. In this November 20, 1861, letter, he thanks Illinois Congressman Elihu Washburne for his support: "The very flattering interest you have taken in my personal welfare and advancement I know of but one way of repaying…I promise the country my undivided time and exertions." *On loan from the Gilder Lehrman Institute of American History*

RIGHT / *A great army*

On January 2, 1865, Grant wrote to James L. Crane, chaplain of the 21st Illinois regiment, which was Grant's first command of the war. He reminisced about how the regiment—and the Union Army as a whole—had grown since the beginning of the war: "We now have an army of soldiers such as the world never saw before." *On loan from the Gilder Lehrman Institute of American History*

Although my cares have
increased since we last
met I take life about
as easy as I did trying
to bring the old 21st,
and its Chaplain, into
the traces. I have often
thought how supremely
contemptuously the 21st
now would look upon
a body of men as green
as they were then. We
now have an Army of
Soldiers such as the
world never saw before.
When we get this little

RIGHT / *Laying siege*
In this May 31, 1863, letter to 16th Corps Commander
Stephen Hurlbut, Grant outlines plans for taking Vicksburg,
Mississippi, a Confederate stronghold: "Vicksburg is so strong
by nature and so well fortified that…it must be taken by
regular siege or by starving out the garrison." Less than
two months later, Vicksburg fell. The campaign led to one
of the Union's greatest victories—and ultimately to Grant's
elevation to General-in-Chief of all Union Armies. *On loan
from the Gilder Lehrman Institute of American History*

Head Quarters, Dept. of the Ten.
Near Vicksburg, May 31st 1863

Maj. Gen. S. A. Hurlbut
Comd'g 16th Army Corps.
Gen.

I send this
by Col Hillyer of my Staff to
insure it reaching you speedily and
that he may urge upon you the
necessity of the very promptest action.

Vicksburg is so strong by nature
and so well fortified that sufficient
force cannot be brought to bear against
it to carry it by storm against the
present Garrison. It must be taken
by a regular siege or by starving
out the Garrison. I have all the
force necessary for this if my rear
was not threatened.

It is now certain that Jo Johnston
has already collected a force from twenty
to twenty five thousand strong at
Jackson & Canton and is using every
effort to increase it to forty thousand.
With this he will undoubtedly attack
Haines Bluff and compel me to
abandon the investment of the city if
not reinforced before he can get here.
I want your District stripped to the
very lowest possible standard. You can
be in no possible danger for the
time it will be necessary to keep these
troops away. All points in West Ten-
nessee North of the Memphis & Charles-
ton road, if necessary, can be abandoned
entirely. West Kentucky may be reduced
to a small Garrison at Paducah and

Columbus.

If you have not already brought
forward the troops to Memphis to send me
bring Smith's, formerly Lauren's, Division.
Add to this all other force you can
possibly spare. Send two regiments
of Cavalry also. If you have not
received the Cavalry last ordered from
Helena direct them to this place
instead of sending two other regiments.

No boat will be permitted to leave
Memphis going North until transportation
is fully provided for all the troops
coming this way. The Quartermaster in
charge of transportation and Col. W. S.
Hillyer are specially instructed to see
that this direction is fully enforced.

The entire rebel force heretofore against
me are completely at my mercy. I do
not want to see them escape by being
reinforced from elsewhere.

I hope before this reaches you troops
will be already on the way from your
Command.

Gen. Dodge can spare enough from
his force to Garrison Lagrange & Grand
Junction.

Very respectfully
U. S. Grant
Maj. Gen.
Com.

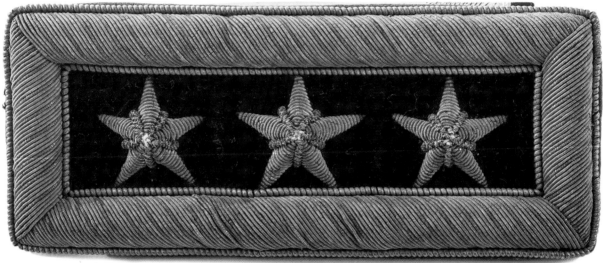

CWMP 86.13.8

Highest rank

Grant's shoulder strap, consisting of velvet and gold bullion and bearing his rank insignia of lieutenant general, the highest held by any Union officer in the war. He wore this on the simple frock coat of a private after his promotion. He told a comrade that the art of war was simple: "Find out where your enemy is. Get at him as soon as you can. Strike him as hard as you can, and keep moving on."
On loan from the Civil War Museum of Philadelphia

Signing a nation's future

The gold and ivory pen used by Lincoln to sign
the Lieutenant General's commission for Grant on
March 10, 1864. The top of the pen point is engraved,
" 'Vicksburg' Lieut. Genl. Grant U.S. Army." *On loan
from the Civil War Museum of Philadelphia*

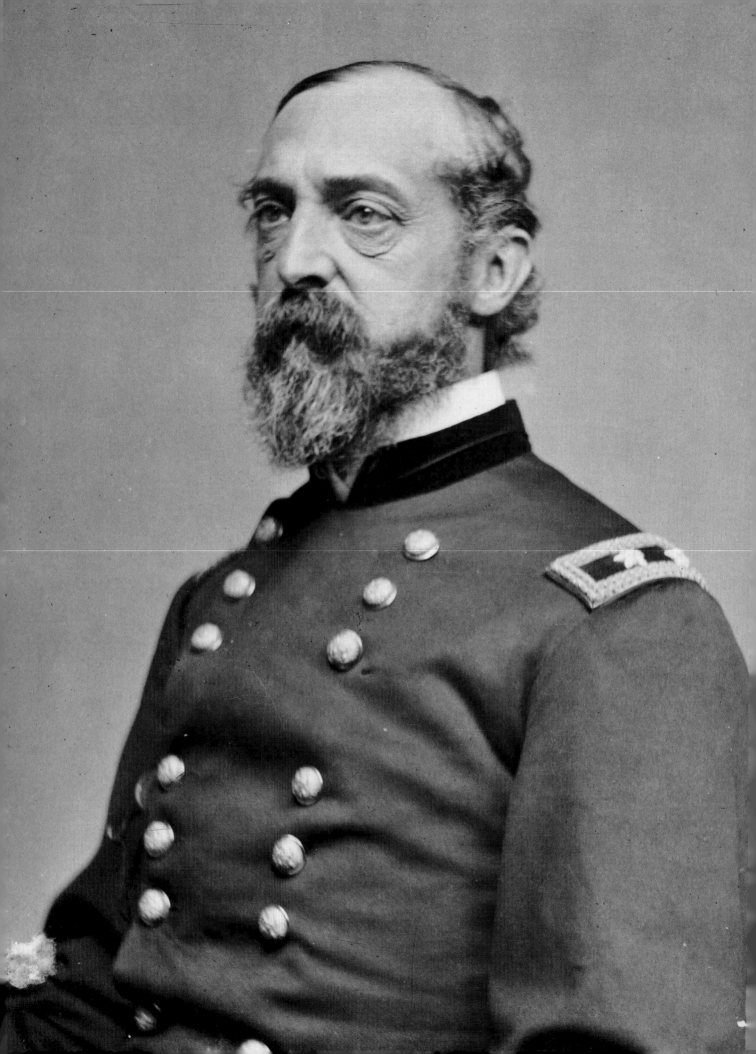

The papers are making a great deal too much fuss over me. I claim no extraordinary merit for the last battle [Gettysburg]…it was…in my judgment, a most decided victory, though I did not annihilate or bag the Confederate army.

—George Gordon Meade

GEORGE GORDON MEADE
1815–1872
Union Army General

The first Union general to hand Lee's army a solid defeat in the largest battle of the war, George Meade never sought a career in the military. He went to West Point to become an engineer, not a general.

When war broke out, the North needed leaders and Meade received promotion to brigadier general. Meade soon showed he could handle command as well as a compass—and his solid performance soon led to his promotion to command of the 5th Corps. Early on June 28, 1863, a courier awakened Meade with a message that changed his career—and the country's fate: Lincoln made him commander of the Union Army of the Potomac. At Gettysburg three days later, Meade battered Lee's army into defeat. When he saw that Lee's final attack in the battle had been turned back, Meade said simply, "Thank God."

It was the first major defeat of Confederate forces in the war's eastern theater, but it was incomplete because Meade allowed Lee to escape—prolonging the war. Lincoln did not accept Meade's offer to resign, but he promoted another officer over him by naming Ulysses Grant General-in-Chief of all Union Armies.

Meade served capably under Grant's direction for the duration of the war. Although Grant spoke highly of him, Meade remained in his boss' shadow—to the point that many students of history still believe Lincoln fired him after Gettysburg.

GEORGE GORDON MEADE
1815–1872

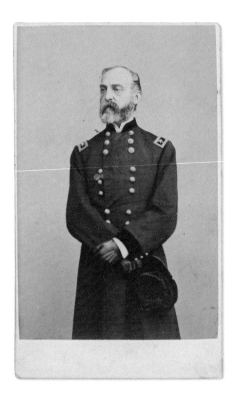

Born
- Cadiz, Spain

Claim to fame
- First Union Army commander to defeat Robert E. Lee's Confederate Army of Northern Virginia (at Gettysburg)
- Last and longest-standing commander of the Army of the Potomac

Education
- U.S. Military Academy at West Point (19/56 in his class)
- Harvard University, honorary law degree

Nicknames
- Damned Old Goggle-Eyed Snapping Turtle

Horse(s) in Civil War
- Baldy/Old Baldy (favorite), Blackie, Gertie, Old Bill. Also rode Slicky, Alfred Pleasonton's horse, Gettysburg, Day 2

First military assignment
- 3rd U.S. Artillery, Seminole Wars, Florida

Family
- Wife, Margaretta Sergeant, daughter of Henry Clay's presidential running mate John Sergeant
- Seven children: four boys, three girls
- Son George was his aide-de-camp at Gettysburg

Personal characteristics
- Tall and thin, grizzled beard, salt-and-pepper thinning hair
- Blue eyes, near-sighted
- Plain dresser

Personal trivia
- Could never run for president because not born in United States
- Got married on his 25th birthday, New Year's Eve in 1840
- Bad temper
- Designed Cape May Lighthouse, New Jersey
- Designed Barnegat Lighthouse (1859), featured today on New Jersey shore conservation license plate
- Designed a special hydraulic lighthouse lamp
- After the war, Philadelphia admirers took up a collection to give him a nicer home. Meade rejected the offer; Mrs. Meade accepted. The mansion still stands at Delancey Place and 19th Street with "Meade" carved over the main entrance.
- Actor Matthew Fox (*Lost*, *Party of Five* television shows) is a Meade descendant
- U.S. Liberty Ship (World War II) SS George G. Meade is named in his honor
- U.S. Army Fort George G. Meade in Maryland and Meade County, Kansas, are named for him
- Although nine years younger than Robert E. Lee, outlived him by only two years
- Died from pneumonia brought on by old war wounds
- Gravestone reads: "He did his work well, and is at rest"

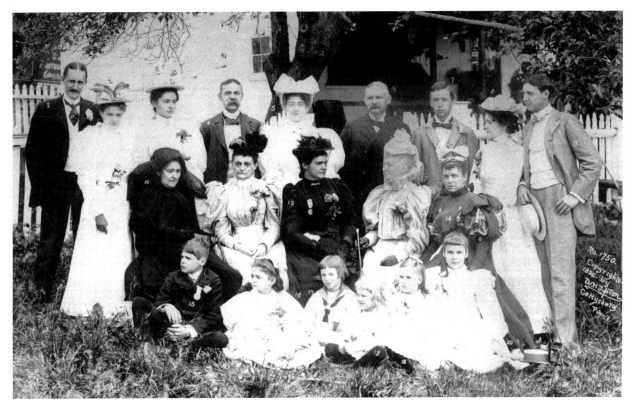

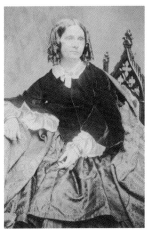

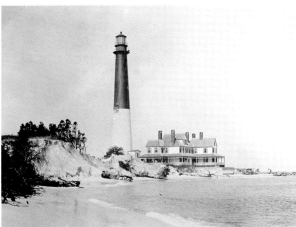

ABOVE / Meade descendants in front of the Leister House, his headquarters during the Battle of Gettysburg in 1863. Gettysburg resident and photographer William H. Tipton took this 1896 picture.

LEFT / Barnegat Lighthouse, New Jersey, c. 1920. As an Army engineer, Meade designed several lighthouses, including Barnegat—commissioned in 1859. It is now on the National Register of Historic Places.

ABOVE / Meade's wife, Margaretta, 1860. A devoted family man, Meade frequently wrote to her and their children throughout the war. *Courtesy of Anthony Waskie and the General Meade Society*

LEFT / Commander of the Union Army of the Potomac, Maj. Gen. Meade in front of his tent, 1864. *National Archives*

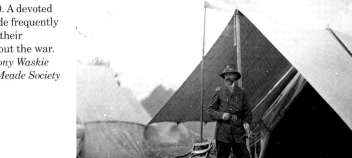

Hd. Qrs. A. P.
10. P. M. Sear. 15. /63

Maj. Genl. Pleasanton. -

What reason have you for supposing
the enemy will attempt to drive
you back with infantry? -
I am not yet prepared to move
the whole army forward awaiting
instructions from Washington, but
if you have reason to believe, or
have any evidence that Lee will
cross the Rapidann to give me
battle between the two rivers, it
would prove his having a greater
force than we have supposed &
would militate against the
retrograde movement.

Geo. G. Meade
Maj. Genl. -

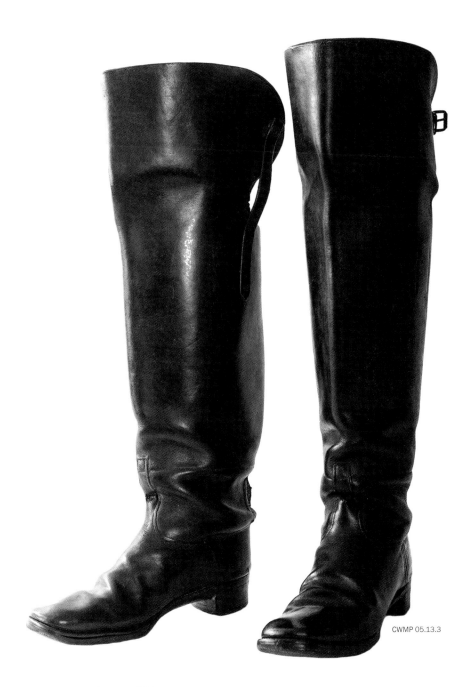

CWMP 05.13.3

ABOVE / *In the saddle*
Meade's high-cut leather officer's boots. Both Meade
and his favorite horse Baldy sustained several wounds
throughout the war. *On loan from the Civil War Museum
of Philadelphia*

LEFT / *On the move*
Meade pursued Lee into Virginia after Gettysburg.
In this September 15, 1863, letter, Meade asked his cavalry
corps commander, Alfred Pleasonton, for evidence of Lee's
movements near the Rapidan River—a sign that, in
Meade's words, "would prove his having a greater force
than we have supposed." Meade also believed Lee had
superior numbers at Gettysburg, when in truth Lee's
army was smaller—by almost 20,000 soldiers. *On loan
from the Gilder Lehrman Institute of American History*

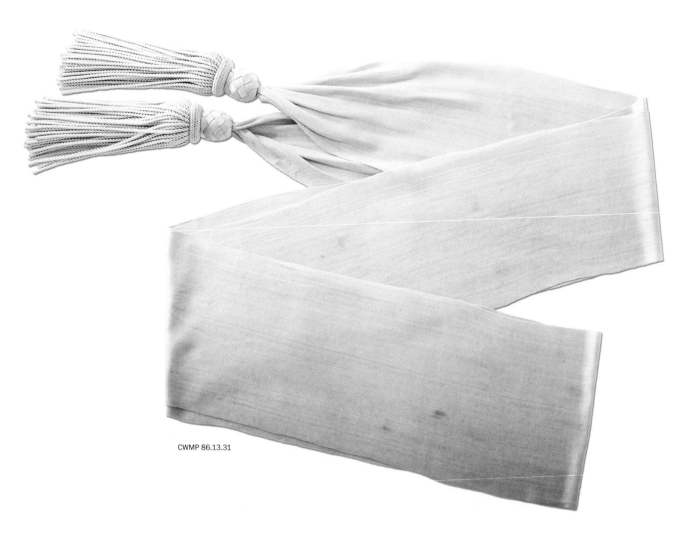

CWMP 86.13.31

ABOVE / *Straight shooter*
Meade's gold silk general officer's sash. Meade was known for his direct manner in all things, including appearance. *On loan from the Civil War Museum of Philadelphia*

RIGHT / *Windows to the soul*
General Meade's eyeglasses. Near-sighted, Meade had blue eyes described by a comrade as having an expression nearly always "serious, almost sad." *On loan from the Civil War Museum of Philadelphia*

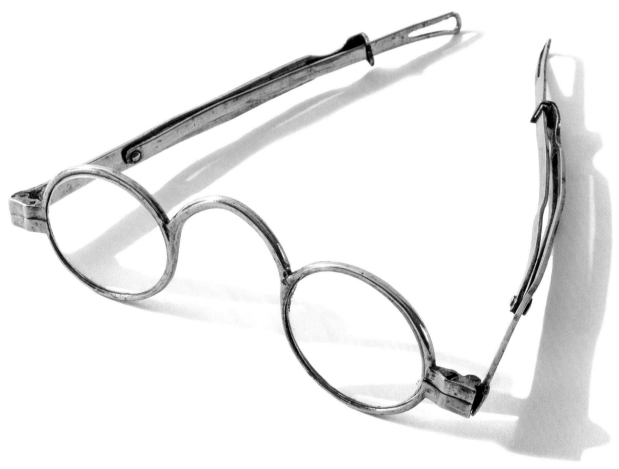

CWMP 93.13.1

GLC 08902

Last chance

The autumn after Gettysburg, Lincoln pressed Meade to go on the offense against Lee. In this November 2 letter to General-in-Chief Henry Halleck, Meade outlines his strategy to attack Lee's right. The resulting Mine Run Campaign went well at first—but delays and poor weather snatched the element of surprise from Meade, allowing Lee and his army to get away. It was Meade's last planned offensive before he received a new boss in Grant the following spring. *On loan from the Gilder Lehrman Institute of American History*

GLC 02983

Rising through the ranks

Meade was a brigadier general in February 1862 when he
signed this muster roll of Company D, 11th Pennsylvania
Reserves. By Christmas Day that year, he was promoted
to command the 5th Corps of the Army of the Potomac.
Little more than six months later, his star rose again
when Lincoln named him commander of the Army of the
Potomac days before Gettysburg. *On loan from the Gilder
Lehrman Institute of American History*

Head Quarters Army of the Potomac,
JULY 4th, 1863.

GENERAL ORDERS }
NO. 68. }

THE Commanding General, in behalf of the country, thanks the Army of the Potomac for the glorious result of the recent operations.

An enemy superior in numbers and flushed with the pride of a successful invasion, attempted to overcome and destroy this Army. Utterly baffled and defeated, he has now withdrawn from the contest. The privations and fatigue the Army has endured, and the heroic courage and gallantry it has displayed will be matters of history to be ever remembered.

Our task is not yet accomplished, and the Commanding General looks to the Army for greater efforts to drive from our soil every vestige of the presence of the invader.

It is right and proper that we should, on all suitable occasions, return our grateful thanks to the Almighty Disposer of events, that in the goodness of his Providence He has thought fit to give victory to the cause of the just.

By command of
MAJ. GEN. MEADE.

S. WILLIAMS, Asst. Adj. General.

CWMP 86.38.2

Well done

The day after the Union Army's victory at Gettysburg, Meade issued these orders congratulating his troops on their first major defeat of the Confederates under Lee. He cautioned the army that their task "to drive from our soil every vestige of the presence of the invader," was not completed—a phrase that infuriated Lincoln, who remarked to Maj. Gen. Henry Halleck that all of America was still "our soil." *On loan from the Civil War Museum of Philadelphia*

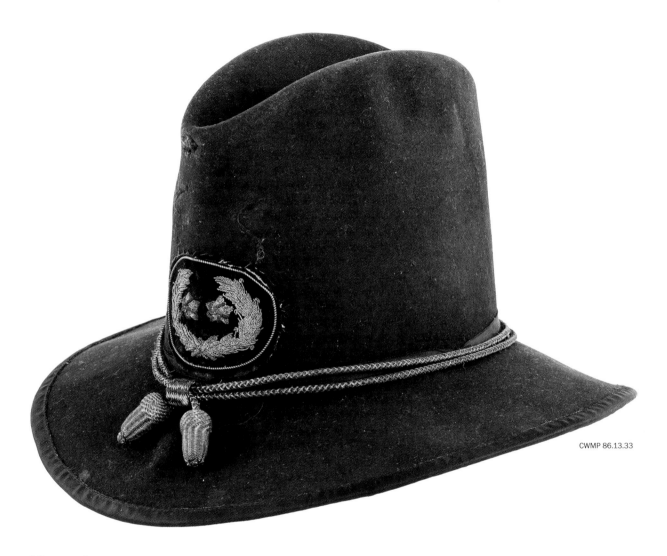

CWMP 86.13.33

Near miss

Officer's wool felt slouch hat worn by Meade at Gettysburg.
The crown of the hat is pinched in "campaign" style. Generals
and line officers often preferred the slouch hat for its wide
brim, which provided better protection and, in the Eastern
theater of war, signified rank (since most ordinary soldiers
wore the regulation forage cap). At Fredericksburg as Meade
led troops in a successful offensive against Confederates,
two bullets pierced this hat but did not injure him.
On loan from the Civil War Museum of Philadelphia

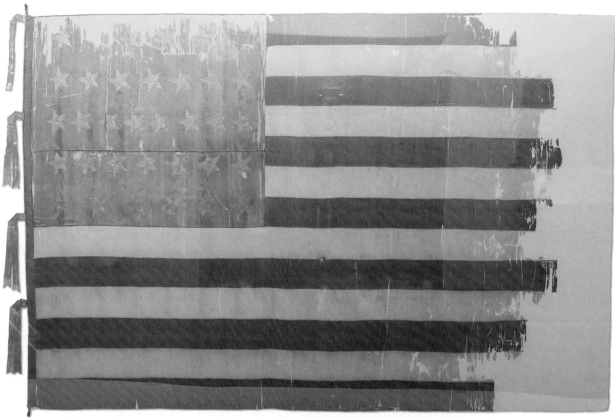

CWMP 86.2.4

ABOVE / *Commanding colors*
At Gettysburg, Meade led the Union Army to its first major
victory of the war in the eastern theater, only days after
he took command. This silk flag rose and stayed aloft over
Meade's headquarters throughout the bloodiest battle of the
war. *On loan from the Civil War Museum of Philadelphia*

RIGHT / *In appreciation*
Detail of Meade's sword from a presentation sword and
scabbard set produced by Bailey and Co., Philadelphia,
with blade by W. Clauberg, Soligen (present-day Germany).
Of gold and steel, the set features adornments in diamonds
and blue enameling—including Meade's initials, "G.G.M."
Although best remembered as the victor of Gettysburg,
Meade also performed well as a leader in other battles.
On loan from the Civil War Museum of Philadelphia

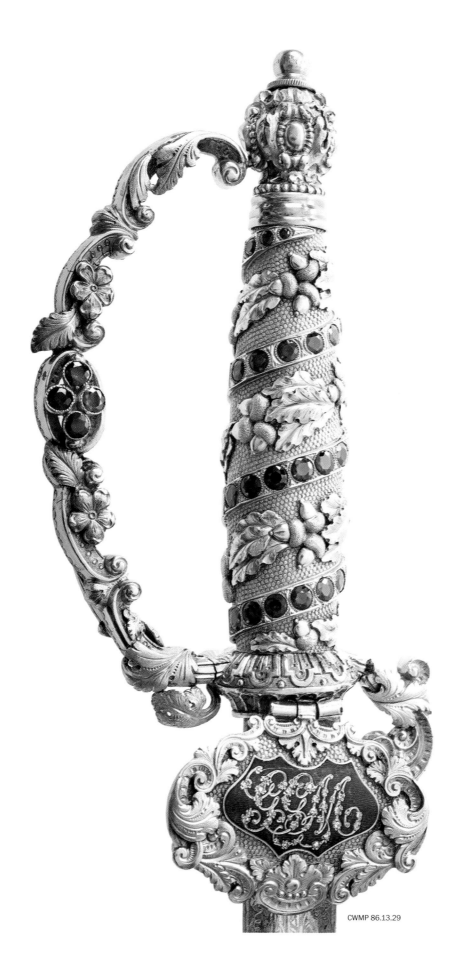

CWMP 86.13.29

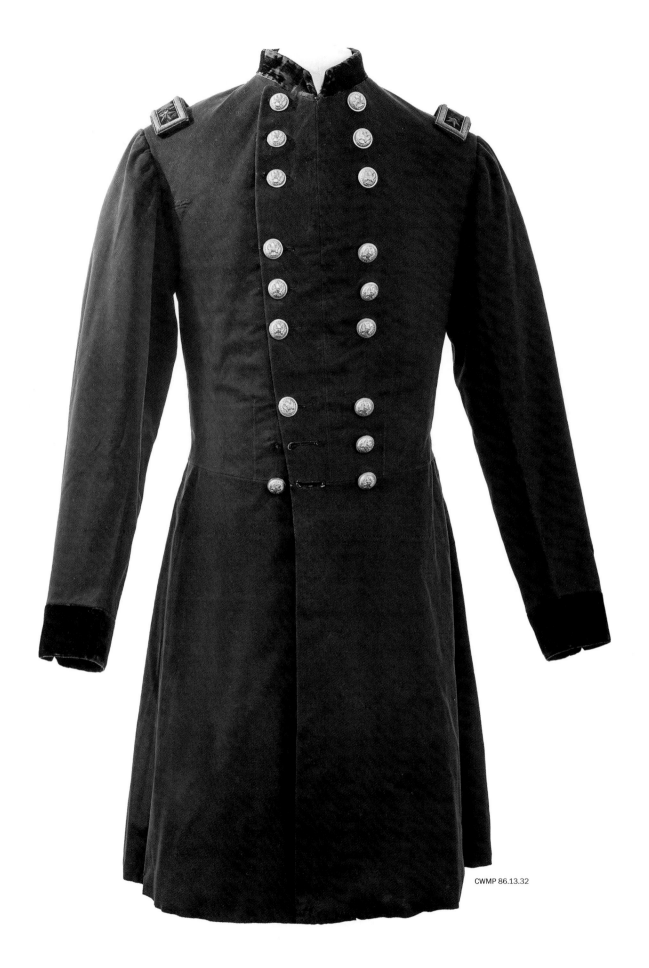

CWMP 86.13.32

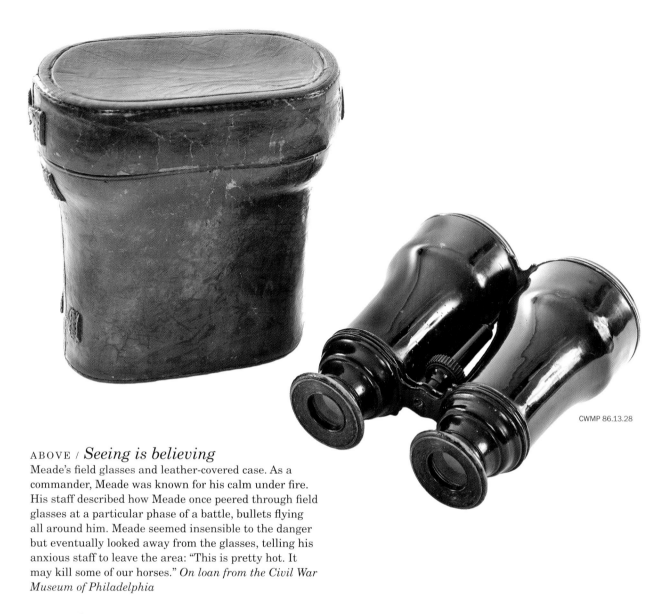

CWMP 86.13.28

ABOVE / *Seeing is believing*

Meade's field glasses and leather-covered case. As a
commander, Meade was known for his calm under fire.
His staff described how Meade once peered through field
glasses at a particular phase of a battle, bullets flying
all around him. Meade seemed insensible to the danger
but eventually looked away from the glasses, telling his
anxious staff to leave the area: "This is pretty hot. It
may kill some of our horses." *On loan from the Civil War
Museum of Philadelphia*

LEFT / *General attire*

The uniform frock coat worn by Meade at Gettysburg,
complete with two major general's shoulder straps.
After the Union Army's loss at Chancellorsville under
Maj. Gen. Joseph Hooker in May 1863, Union generals
with rank superior to Meade speculated who Lincoln
would place in command if he removed Hooker. Said one:
"Why, Meade is the proper one to command this army."
On loan from the Civil War Museum of Philadelphia

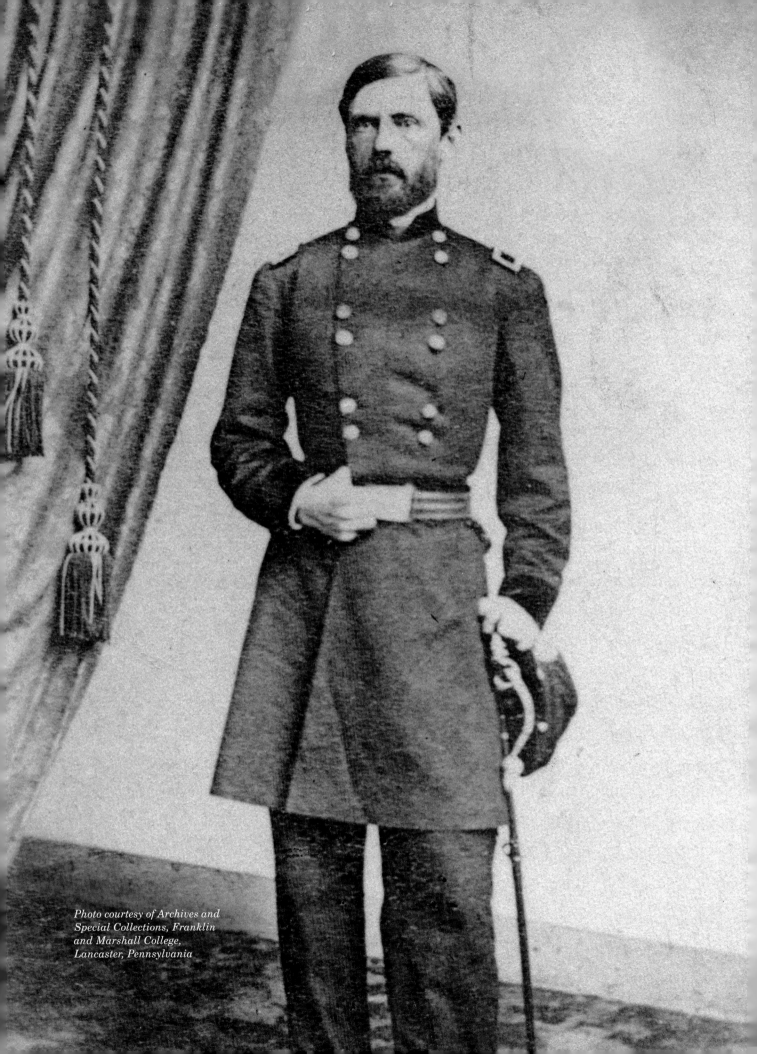

I will fight them inch by inch, and if driven into [Gettysburg], I will barricade the streets and hold them back as long as possible.

—John Fulton Reynolds

JOHN FULTON REYNOLDS
1820–1863
Union Army General

With Lee's forces invading Pennsylvania in summer 1863, Lincoln ordered John Reynolds' friend and rival George Meade to command the Army of the Potomac—a post Reynolds already had turned down. Early in the war, he had established a reputation for leading—not driving—his troops, often exposing himself to enemy fire in the process.

He loved the army but hated army politics, privately pouring out his frustration in letters home about politicians trying to run the fight from Washington. When tapped to drill emergency militia by the governor to protect Pennsylvania as Confederates drew closer in a first attempt to invade the state, Reynolds' irritation nearly spilled out in public because he missed the main event in Maryland—the Battle of Antietam.

When Lee attempted a second invasion, Meade showed confidence in his friend's ability by placing nearly a third of the army under his command on June 30. Reynolds was ordered to Gettysburg on July 1—and when he encountered the Confederate army that morning, he audaciously engaged them outside of town. He led from up front, where he could inspire his men. It cost him his life.

Word of his death spread quickly across the country. His courageous actions to safeguard key high ground from the start helped ensure Union victory at Gettysburg, a feat for which Reynolds has sometimes been called "the architect of the battle."

JOHN FULTON REYNOLDS
1820–1863

Courtesy of Archives and Special Collections, Franklin and Marshall College, Lancaster, Pennsylvania

Born
- Lancaster, Pennsylvania

Claim to fame
- Commandant of Cadets, West Point
- Highest-ranking general killed at Gettysburg, one of most senior Union generals killed in the entire war

Education
- Long Green Academy, Baltimore, Maryland
- Lancaster Academy
- U.S. Military Academy at West Point (26/52 in his class)

Nicknames
- Josh (West Point); Old Common Sense, The Old Man (his troops)

Horse(s) in Civil War
- Fancy (favorite), Prince

First military assignment
- Fort McHenry, known for War of 1812 defense of Baltimore Harbor against British and inspiration for the "Star Spangled Banner"

Family
- Parents, 12 brothers and sisters (seven lived to adulthood)
- Father was captain of local militia and a journalist; brother became a rear admiral in U.S. Navy
- Grandfather served in Revolutionary War infantry; survived winter encampment at Valley Forge
- Betrothal (secret) to Catherine Mary Hewitt (Kate), former governess he met likely while posted in San Francisco. If Reynolds survived the war, they planned to marry and honeymoon in Europe.

Prized possession
- Gold pinky ring with "Dear Kate" inscribed inside; it was on his finger when he died

Pet
- Milo, his dog when posted at Fort Preble, Maine, in 1850s

Personal characteristics
- Tall (about 6 feet), "piercing" dark eyes/hair, tan complexion

Personal trivia
- Favorite sibling: baby sister Ellie
- Didn't have a good sense of humor
- Hated paperwork
- Considered one of the best horsemen in the Union Army
- Almost court-martialed George Custer at West Point for disciplinary/ academic infractions
- Friends with William Tecumseh Sherman at West Point
- Didn't get along with journalists
- Described as "alertness personified" by one of his soldiers
- Pre-war family friends of James Buchanan, 15th President of the United States, who he and siblings secretly called "Mr. Buckwheat"
- Has three monuments on Gettysburg battlefield dedicated to him and has a portrait statue featured on Pennsylvania Memorial there— the most of any Union commander

LEFT / Reynolds pictured in his mid- to late 20s during the Mexican War, during which he received two brevet promotions for gallantry. *Courtesy of Archives and Special Collections, Franklin and Marshall College, Lancaster, Pennsylvania, and the estate of Anne Hoffman Cleaver*

BELOW / Lydia Moore Reynolds, one of John's sisters. He wrote to his sisters throughout the war, often venting his frustrations about civilian leaders. *Courtesy of the estate of Anne Hoffman Cleaver*

RIGHT / Kate Hewitt, the general's fiancé. His family did not learn of their betrothal until after his death at Gettysburg. *Courtesy of Archives and Special Collections, Franklin and Marshall College, Lancaster, Pennsylvania*

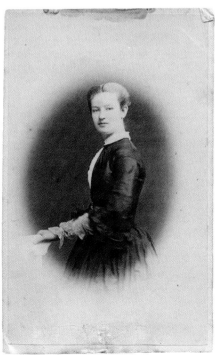

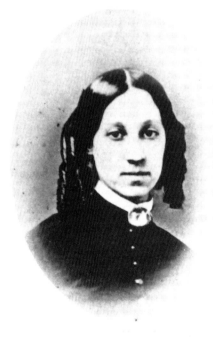

Head Qrs. 1st Army Corps
October 24, 1862

Brig. Gen. H. J. Hunt
Chief of Arty., Army of Potomac

General,

I have sent round to all the Batteries of the Corps, to-day, & find no vacancies of Lieutenancies, anywhere. The only vacancy is a Captaincy in the 1st Penn. Battery "G." I am very sorry that I am not able to oblige you, in the matter.

Very respectfully
John F. Reynolds
Brig. Genl. Vols.
Army

GLC 02462.19

Leading by example
Written from headquarters on October 24, 1862, this letter from Reynolds to artillery commander Henry J. Hunt reports no vacancies at the lieutenant level in the 1st Corps. One of his staff wrote that Reynolds' troops were fond of him—in great measure because he led by example, out in front. *On loan from the Gilder Lehrman Institute of American History*

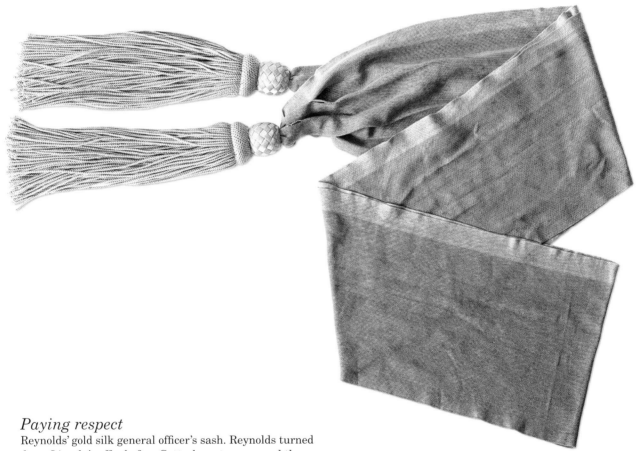

GETT 44745

Paying respect

Reynolds' gold silk general officer's sash. Reynolds turned
down Lincoln's offer before Gettysburg to command the
Union Army of the Potomac. When Reynolds learned
that his friendly rival Meade had been given the nod, he
immediately put on his full dress uniform—which would
have included his sash—and went to Meade's tent to
congratulate and offer support to his new commander.
Gettysburg National Military Park, National Park Service

CWMP 86.10.1

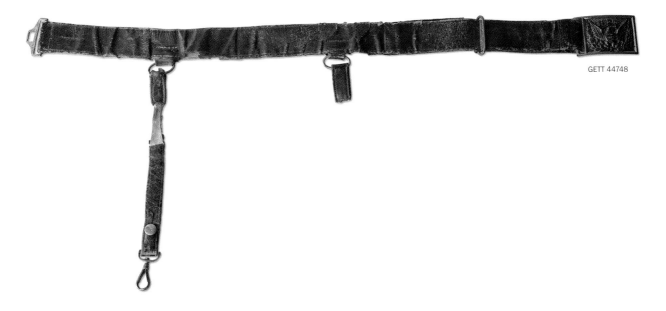

GETT 44748

ABOVE / *Loss of a giant*
Reynolds' private purchase sword belt and buckle
incorporates elements of the Model 1851 officer's sword
belt and features an inscribed "R" on the remaining
sword hanger. One month after the battle, Maj. William
Riddle of Reynolds' staff wrote to Reynolds' sisters about a
Confederate officer's view of the impact of Reynolds' death.
Taken prisoner during the battle, the officer relayed that
the "[Confederates] could far better spare [Stonewall]
Jackson than we could Reynolds." *Gettysburg National
Military Park, National Park Service*

LEFT / *On this spot*
The hand-carved original wooden plaque marked the spot
where Reynolds was killed at Gettysburg. The message,
written in ink, reads: "Gen. Reynolds Killed July 1 1863."
When Meade, commander of the Union Army of the
Potomac, learned of Reynolds' death, he said he would
"rather have lost twenty thousand men, for the country's
sake, than Reynolds." *On loan from the Civil War Museum
of Philadelphia*

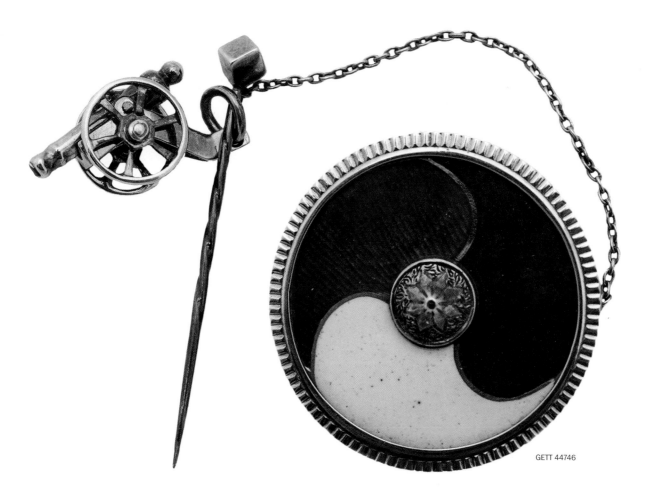

GETT 44746

ABOVE / *Badge of honor*
Commander of the Union 1st Corps, Reynolds designed
a tri-colored badge symbolizing the unity of the corps'
three divisions. His sister later commissioned this pin
for Reynolds based on his original design. The enamel pin
features a gold backing engraved with his initials, "J.F.R."
Said Captain R.K. Beechem: "We soldiers of the first corps
were very fortunate that our general had not only common
sense, but sufficient humanity in his heart to use it."
Gettysburg National Military Park, National Park Service

RIGHT / *Hands-on leadership*
Reynolds' Model 1860 field and staff sword. A general
who believed that effective army direction belonged to
commanders on the field rather than civilian leaders in
Washington, D.C., Reynolds largely kept this view private.
Yet he revealed it in correspondence with his sisters in
1862: "…no one can conduct a campaign at a distance
from the field or without being in the actual presence of
the operating armies." *Gettysburg National Military Park,
National Park Service*

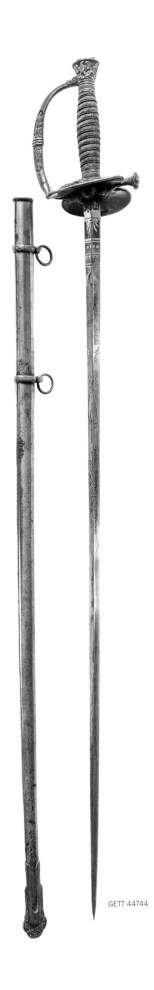

GETT 44744

CWMP 86.9.7

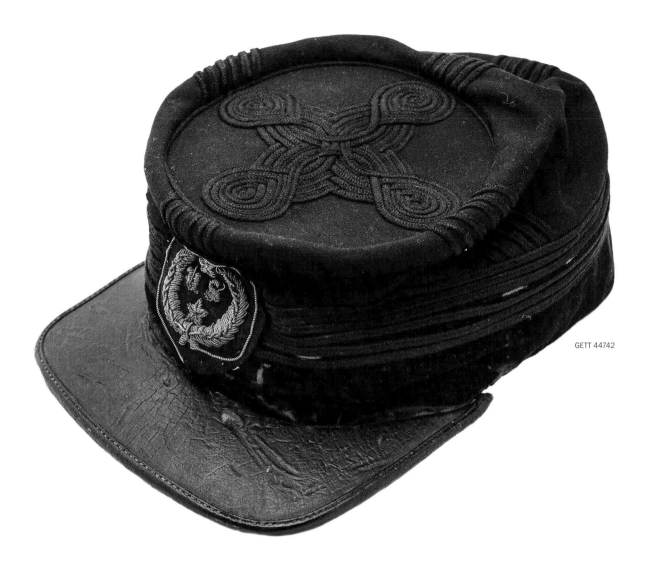

GETT 44742

ABOVE / *Streamlined for battle*
Chasseur-style wool and leather kepi worn by Reynolds
when he lost his life at Gettysburg. Many officers in both
armies—from Reynolds to Stonewall Jackson—preferred
the lighter kepi to the slouch hat. American Civil War
kepis were an adaptation of French and Hungarian
soldiers' hats of the early 19th century. *Gettysburg
National Military Park, National Park Service*

LEFT / *Forward into the fire*
Descendants believe that this is the saddle Reynolds rode
when he was killed at Gettysburg leading the first Union
infantry on the scene into battle. It is a western-style
saddle and differs markedly from typical officers' saddles
of the time. Reynolds most likely obtained it during his
service in the West prior to the Civil War. Wrote orderly
Charles Veil "…whenever the fight raged the fiercest,
there the general was sure to be found." *On loan from
the Civil War Museum of Philadelphia*

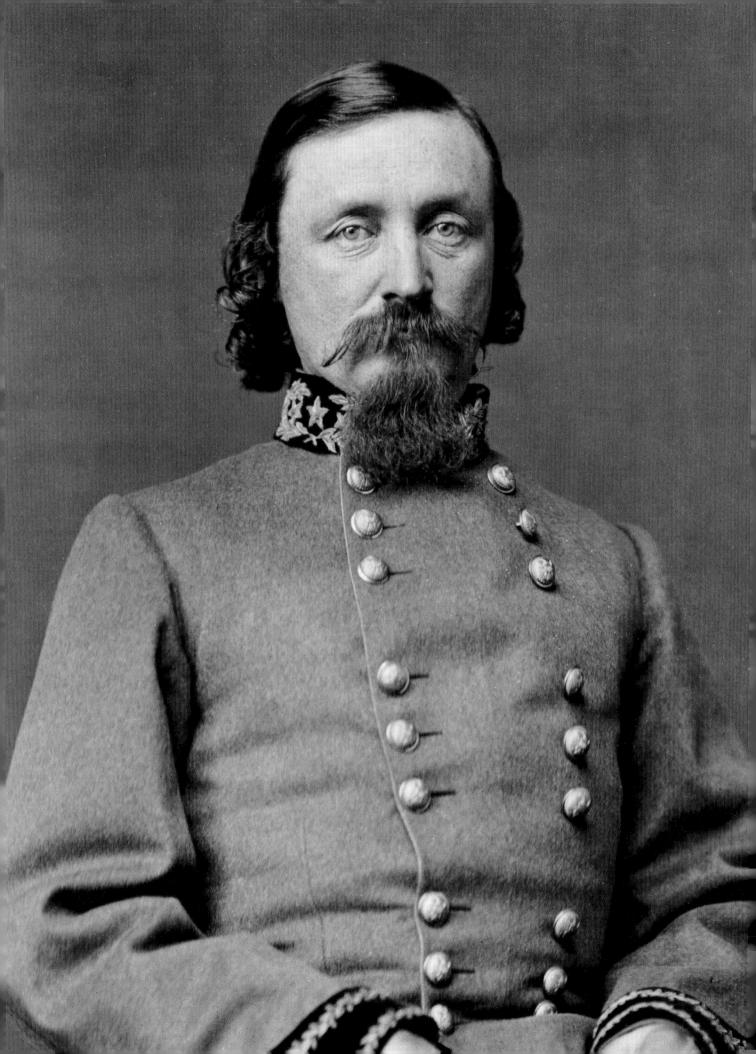

It is all over now. Many of us are prisoners, many are dead, many wounded, bleeding and dying. Your soldier lives…and but for you…he would rather be back there with his dead.

—George Edward Pickett

GEORGE EDWARD PICKETT
1825–1875
Confederate Army General

Few battles in history, let alone few portions of a battle, bear the names of those who led charges within them. Yet the Confederate attack on the third day at Gettysburg still is known as "Pickett's Charge"—despite the fact that George Pickett did not command it and it was not a charge.

Pickett had attained division command in Lee's army by fall 1862. He showed bravery by his willingness to charge at the front of his men in the Peninsula Campaign, yet most of the time, he or his men were not called into the fray. Gettysburg became Pickett's first chance to lead his division in combat.

Delighted when he learned that Lee planned to use his division for a massive assault on the Union center on the battle's third day, Pickett seemed smitten with the opportunity and unconcerned with the risk. Less than an hour after the assault began, the survivors stumbled back in defeat—and nearly half were casualties. The experience shook him to the core.

In some ways he never recovered from that day. He continued to lead his division until it was destroyed at Five Forks in March 1865. Lee blamed Pickett and relieved him of command, a decision for which Pickett never forgave Lee. When, after the war, he complained of Lee to former Confederate partisan John Mosby, "that old man had my division slaughtered at Gettysburg," Mosby said, "Well, it made you immortal."

GEORGE EDWARD PICKETT
1825–1875

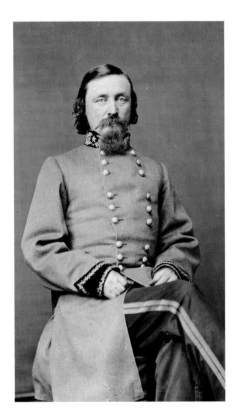

Born
• Richmond, Virginia

Claim to fame
• Led the futile charge that bears his name at Gettysburg, July 3, 1863

Education
• Lancastrian School, Richmond Academy
• U.S. Military Academy at West Point (last in class)

Nicknames
• Great Chief, leader of the "Game Cock Brigade" in fighting during Peninsula Campaign

Personal characteristics
• Perfumed his hair and beard
• Medium height, walked tall and straight
• Carried a riding crop all the time
• Wore an immaculate uniform with gold brocade and gold buttons

Horse(s) in Civil War
• Old Black, Lucy (social occasions only)

Family
• First wife, Sally Harrison Minge, related to Benjamin Harrison (signer, Declaration of Independence) and U.S. President William Henry Harrison, died along with baby daughter in childbirth, 1851
• Second wife, Native American named Morning Mist, died from childbirth complications after 1857 birth of their son James Tilton Pickett (who later became a newspaper artist). Their house in Bellingham, Washington, still stands.
• Third wife, Sallie Corbell, son George Edward Pickett (graduated Virginia Military Institute and served in US Army as paymaster and major, nominated for Medal of Honor for action in the Philippines) and son David Corbell Pickett (died age 8)

Personal trivia
• Grandfather served in Revolutionary War, 1777–1783, in 2nd Virginia Regiment
• Parents sent him to Illinois to study the law under an uncle's tutelage
• Abraham Lincoln's law partner, Illinois Congressman John T. Stuart, nominated Pickett to West Point
• Biggest infractions at West Point: profane language and highly unsoldierly conduct for "walking out on parade grounds, smoking tobacco and improper dress"
• Before the Civil War, challenged future Union commander Winfield Scott Hancock—who faced him in "Pickett's Charge" years later— to a duel. Hancock declined.
• While posted near Puget Sound, Oregon, taught and translated for Native Americans in the area
• The SS George E. Pickett, a liberty transport ship used in World War II, and Fort Pickett—home to Virginia National Guard— are named for him
• After the war, sold insurance in Norfolk, Virginia
• Received a full pardon for his role in the war one year before his death at age 50

LEFT / Pickett's home in Bellington, Washington. He lived here starting in 1856 while a captain with the 9th U.S. Infantry. Five years later, he returned to Virginia to serve with the Confederate Army. The house is the oldest wooden building on its original foundation in Washington State.

BELOW / Sallie "LaSalle" Corbell Pickett, the general's third wife, July 16, 1887. Sallie outlived Pickett by more than 50 years, much of that time devoted to writing about her husband as a hero of the Confederacy.

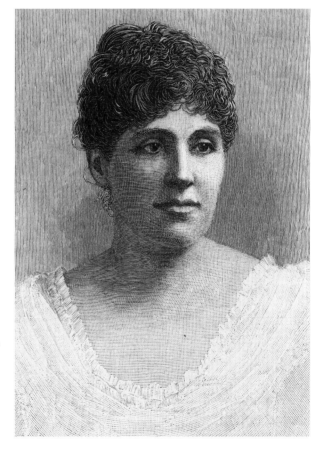

ABOVE LEFT / Pickett's first wife, Sally Harrison Steward Minge. *Courtesy of the Pickett Society*

ABOVE / George Pickett Jr. and David Corbell Pickett, the general's sons with his third wife. *Courtesy of the Pickett Society*

LEFT / James Tilton Pickett, Pickett's only child with his second wife. "Jimmie" became a newspaper artist and a painter. *Courtesy of the Pickett Society*

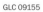

GLC 09155

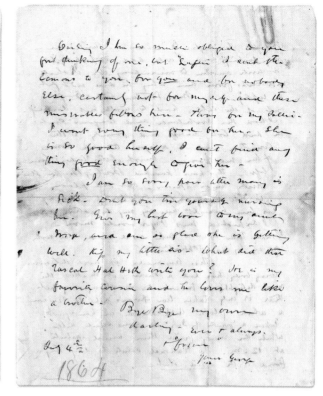

ABOVE / *Prayers home*
This love letter to his third wife, Sallie, was written one
year and one day after Pickett's division's unsuccessful
attack on the Union center at Gettysburg. Just after
midnight he complains that the enemy artillery fired
its usual "national salute" to July 4 with solid shot. He
tells his wife that he detests outward shows of religion,
but offers a "silent prayer with a truthful heart…to our
God to make us better." *On loan from the Gilder Lehrman
Institute of American History*

RIGHT / *Dressed for success*
Described as striking and distinguished, Pickett typically
wore an immaculate uniform featuring spurs like this.
Gettysburg National Military Park, National Park Service

GETT 06280

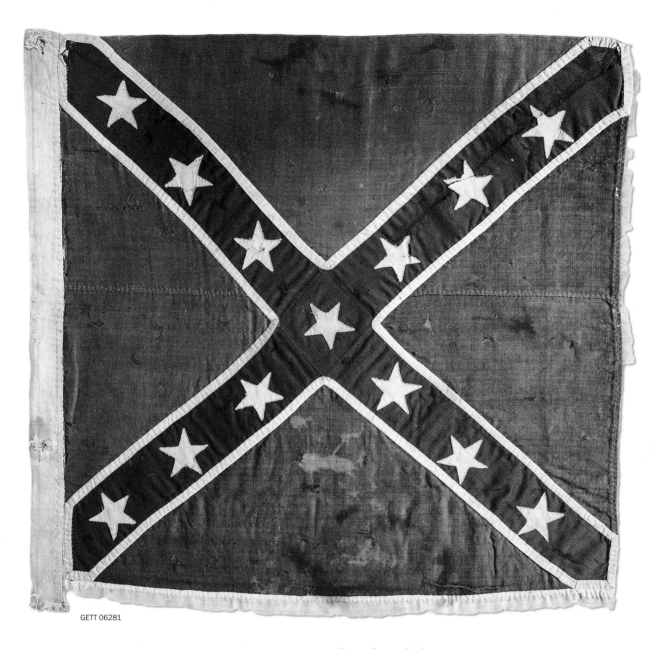

GETT 06281

Resolve aloft
The canton of Pickett's headquarters flag used at
Gettysburg. This was a wool Second Pattern Confederate
National Flag featuring the St. Andrew's Cross and 13
five-pointed cotton stars representing each state in the
Confederacy, plus border states Kentucky and Missouri.
The majority of the white field has been lost, but would
have been twice as long and once as wide as the piece
shown here. *Gettysburg National Military Park, National
Park Service*

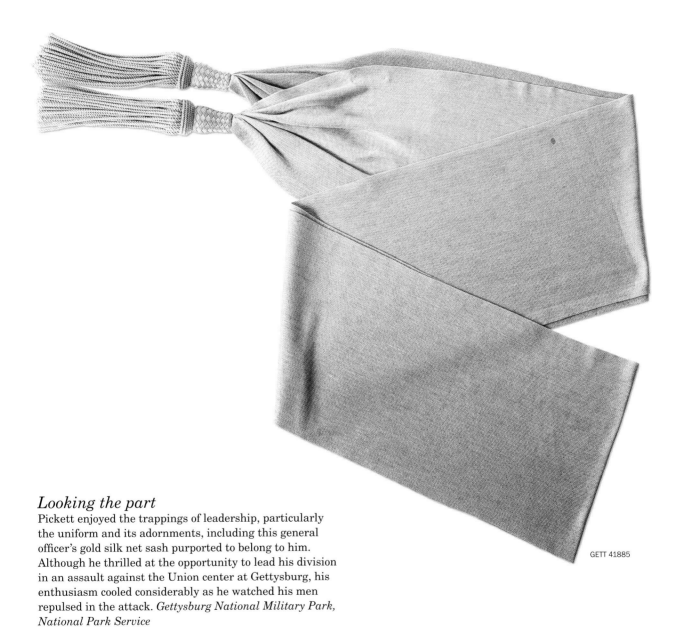

GETT 41885

Looking the part

Pickett enjoyed the trappings of leadership, particularly the uniform and its adornments, including this general officer's gold silk net sash purported to belong to him. Although he thrilled at the opportunity to lead his division in an assault against the Union center at Gettysburg, his enthusiasm cooled considerably as he watched his men repulsed in the attack. *Gettysburg National Military Park, National Park Service*

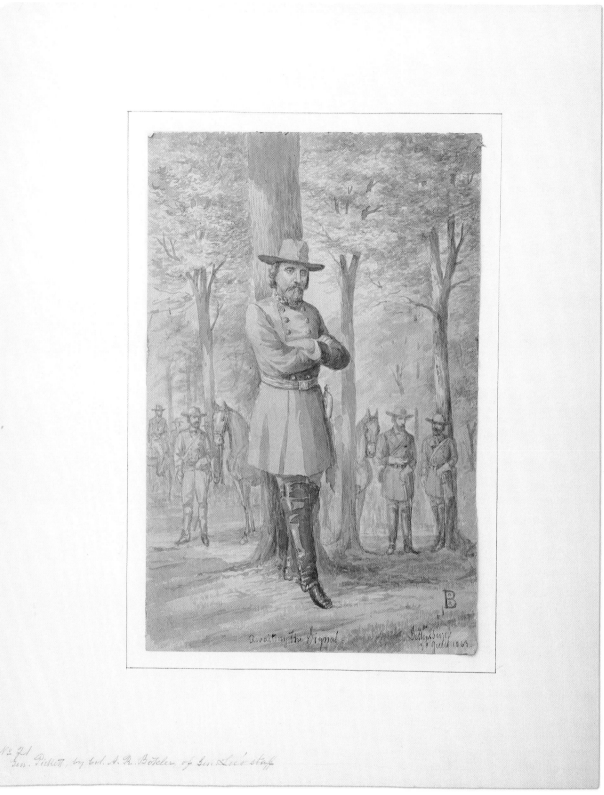

Awaiting the Signal.

Gettysburg
3d July 1863.

No 21
Gen. Pickett by Col. A. R. Boteler of Gen. Lee's Staff

GETT 44026

GLC 09156

ABOVE / *All that remained*
The last return of Pickett's Division on April 9, 1865—the
day Lee surrendered at Appomattox. More than a year and
a half earlier, Pickett led the 5,000+ division in the charge
that eventually bore his name at Gettysburg. By war's end,
the division numbered less than 1,000 soldiers. *On loan
from the Gilder Lehrman Institute of American History*

LEFT / *"Awaiting the signal"*
This watercolor painting over sketch by Col. Alexander
Robinson Boteler Jr.—of Lee's staff—portrays a calm,
confident Pickett waiting in the woods of Seminary Ridge
at Gettysburg for Lt. Gen. James Longstreet's order to
begin the attack on the Union Army center on July 3, 1863.
Gettysburg National Military Park, National Park Service

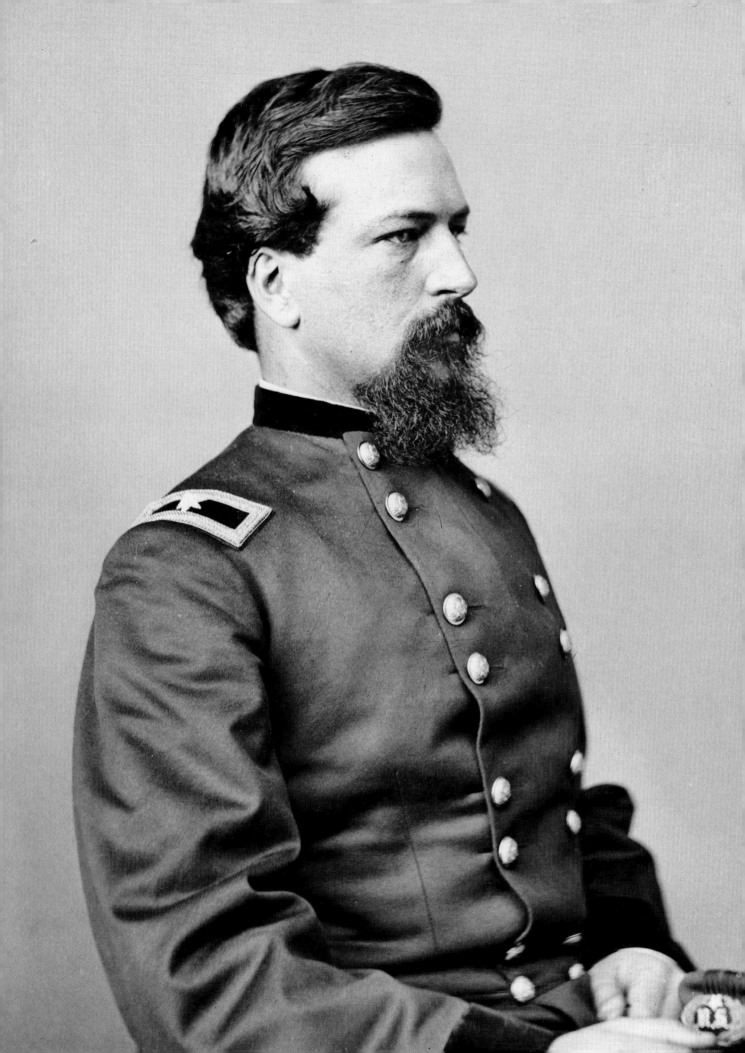

The fate of a country depended on individuals.
My men did not know me. It was necessary to
establish myself...I ordered no man to go where
I would not go myself.

—Alexander Stewart Webb

ALEXANDER STEWART WEBB
1835–1911
Union Army General

Bright West Point graduate Alexander Webb had spent
most of the early war as a staff officer. In June 1863, though,
he won promotion to brigadier general and command of the
Philadelphia Brigade.

The 28-year-old New Yorker was everything his new troops
were not: ramrod straight, groomed and well disciplined.
Skeptical about Webb until Gettysburg's second day, his
soldiers learned he could manage men in battle—and he
had courage under fire. Their supreme test came the next day.

At 1 p.m. July 3, a bombardment pounded their position.
Two hours later, 13,000 Confederates came into view—guiding
toward the center of Webb's position. In the ensuing clash, he
exhorted his men, directing troops to meet the onslaught. At one
point he even tried to seize a regiment's flag to lead men forward.
Webb led a defense like few others—and checked Lee's last
attempt to win the battle. Twenty-eight years later, he received
the Medal of Honor for his leadership in the battle.

Webb led a brigade into Virginia in spring 1864, when at the
Wilderness a bullet struck him in the right eye, passing through
his ear. The wound did not kill him but ended field command
for him. By war's end he was the army's chief of staff. Webb
stayed with the military until 1869, when he traded his uniform
for academic robes, becoming the second president of the
College of the City of New York—a post he held for 33 years.

ALEXANDER STEWART WEBB
1835–1911

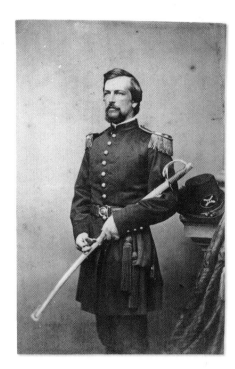

Born
• New York City

Claim to fame
• General who saved the Union center during Pickett's Charge at Gettysburg
• Received Medal of Honor for "distinguished personal gallantry in leading his men forward at a critical period in the contest action" at Gettysburg
• President, College of the City of New York (CCNY), 1869–1902

Education
• U.S. Military Academy at West Point (13/34 in his class)
• Hobart College, honorary law degree

Favorite subjects
• Math and literature

Family
• Wife, Anna Elizabeth Remsen
• Eight children: three sons, five daughters

Pet
• Pointer named Fritz

Personal characteristics
• Dark hair and goatee; tan complexion, always well dressed and groomed; described as "compact" and "comparatively slight"

Personal trivia
• Grandfather was on George Washington's staff and fought at Battle of Bunker Hill, Revolutionary War
• Father was a former army officer; also owned a newspaper and served as a diplomat (minister to Brazil)
• Math professor at West Point
• Attended President Grant's inauguration and served as Grand Marshal of his funeral parade
• First president, Westminster Kennel Club, 1877–1887
• After the war, appointed to role of second president of CCNY; began modernizing curriculum and maintained college as provider of a free public education
• CCNY had contributed to the Union war effort
• Two statues in the United States exist of Webb in military dress: one on Cemetery Ridge, Gettysburg; one on CCNY's campus
• Third statue is a marble bust by renowned 20th century sculptor Roy King in Shepard Hall, CCNY
• Gravestone at West Point reads: "Blessed are the pure in heart, for they shall see God"

LEFT / Alexander Webb while serving his 33rd and final year as the second president of the College of the City of New York. Portrait by George Rufus Boynton, 1902. *Courtesy of the City College of New York, CUNY*

BELOW / Webb and several younger brothers. From left: William Seward Webb, M.D. (who married into the wealthy Vanderbilt family) and Henry Walter Webb, top New York railroad executives; attorney and diplomat George Creighton Webb; and Alexander later in life. *From King's Notable New Yorkers: 1896–1899 by Moses King*

WILLIAM SEWARD WEBB, M.D.

HENRY WALTER WEBB

GEORGE CREIGHTON WEBB

ALEXANDER STEWART WEBB
PRESIDENT COLLEGE OF THE CITY OF NEW YORK (1869–)
BREVET MAJOR GENERAL, U. S. ARMY (1865)

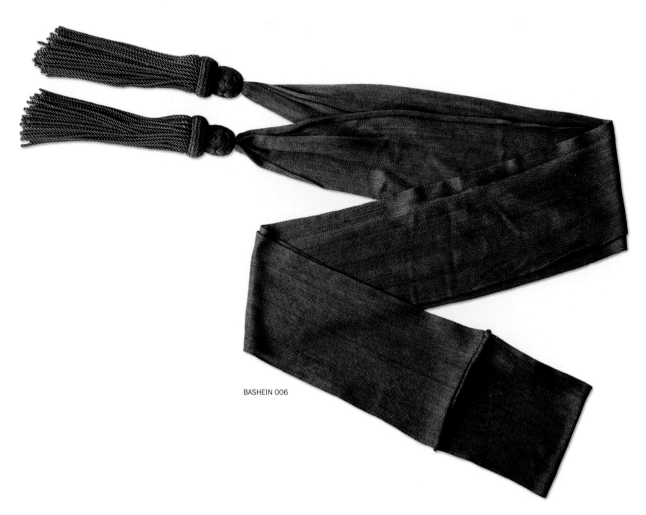

BASHEIN 006

Immaculate

Webb's red silk line officer's sash. Like Pickett—his
Confederate counterpart on the third day of Gettysburg—
Webb always was well dressed and groomed. He had
a reputation as "the most conscientious, hard working
and fearless young officer that we have," according
to Col. Charles S. Wainwright, artillery chief of the
1st Corps, Army of the Potomac. *Gettysburg National
Military Park, National Park Service*

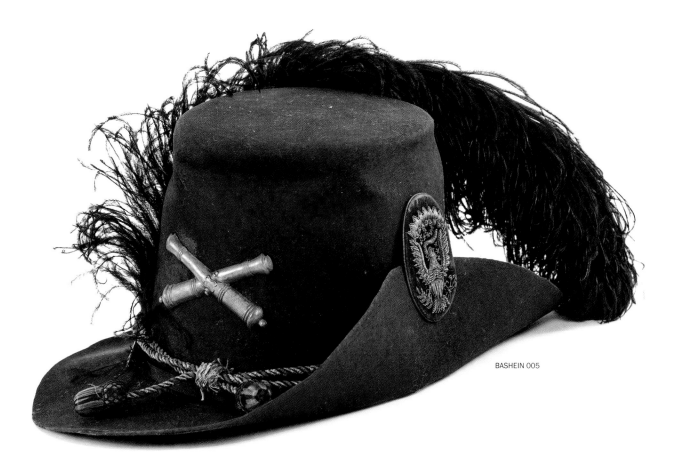

BASHEIN 005

Inspector

Webb became Inspector of Artillery after Antietam in
September 1862. His Model 1858 dress (also known as
"Hardee") hat features the brass field artillery insignia of
crossed cannons. The stamped brass insignia usually was
reserved for enlisted men; Webb most likely placed it on
the hat after the war. *Gettysburg National Military Park,
National Park Service*

RIGHT / *Cool under fire*
This undated carte-de-visite of Webb shows him wearing the line officer's sash featured on page 100. Webb earned his new brigade's trust at Gettysburg in part by showing his cool demeanor under fire. Webb calmly smoked a cigar in the midst of the cannonade that preceded the Confederate attack on July 3, 1863, which one journalist described as "the thundering roar of all the accumulated battles ever fought upon earth." *Gettysburg National Military Park, National Park Service*

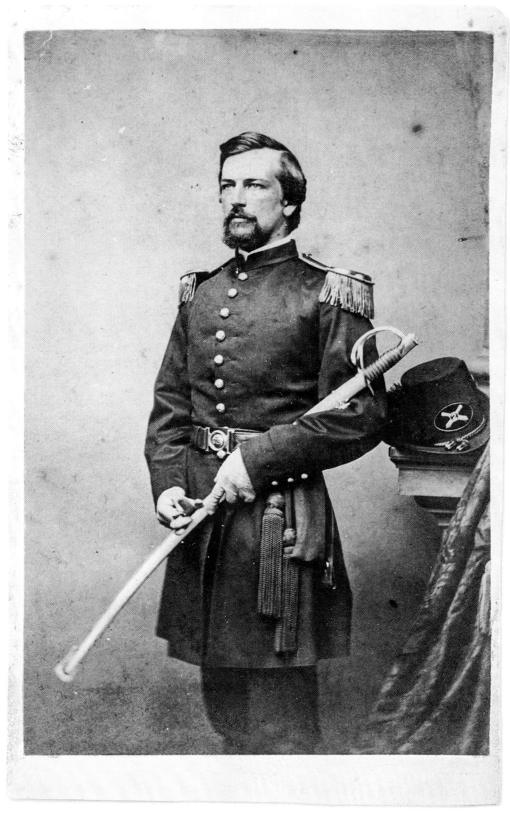

BASHEIN 002

High Water Mark

Nearly 30 years after Gettysburg, Webb drew this sketch (with letter) detailing the Union repulse of the Confederate attack known as "Pickett's Charge." Maj. Gen. Winfield Scott Hancock gave a toast to Webb: "In every battle and on every important field there is one spot to which every army [officer] would wish to be assigned— the spot upon which centers the fortunes of the field. There was but one such spot at Gettysburg and it fell to the lot of Gen'l Webb to have it and hold it and for holding it he must receive the credit due him." *On loan from the Craig Bashein Collection*

BASHEIN 008

A sharp eye

Field glasses belonging to Webb. In the early part of the
war, he served primarily in staff roles, but his performance
in battles earned him promotion to field command of the
Philadelphia Brigade before Gettysburg. Said one of Meade's
staff officers of the new brigade commander, "[Webb] is a
thorough soldier, wide-awake, quick and attentive to detail."
Gettysburg National Military Park, National Park Service

BASHEIN 007

Chief of Staff

Webb's wool and leather chabraque (a formal saddle blanket) denoting his role as Chief of Staff—a position he held for several corps commanders and ultimately for the Union Army of the Potomac. His administrative leadership served him well after the war when he became president of the College of the City of New York. *Gettysburg National Military Park, National Park Service*

BASHEIN 001

Moving up

During the Maryland campaign and Battle of Antietam, Webb served as chief of staff for 5th Corps commander Maj. Gen. Fitz John Porter. Impressed with Webb, Porter wrote this December 6, 1862, letter to Secretary of State William Seward recommending Webb for the position of Inspector General. *Gettysburg National Military Park, National Park Service*

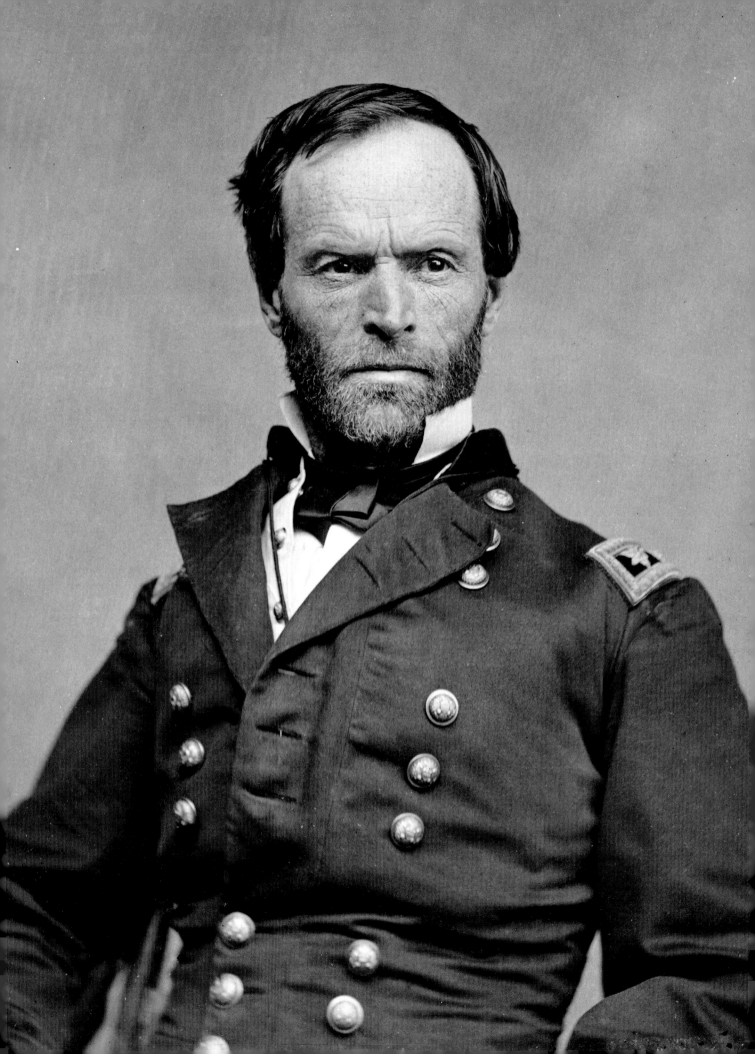

You people of the South don't know what you are doing. This country will be drenched in blood. It is all folly, madness, a crime against civilization! You people speak so lightly of war; you don't know what you're talking about. War is a terrible thing!

—William Tecumseh Sherman

WILLIAM TECUMSEH SHERMAN
1820–1891
Union Army General

William Tecumseh Sherman's father named him for a Shawnee leader he admired. Yet when the elder Sherman dubbed his son Tecumseh—"shooting star" or "panther across the sky"— he could not have foretold his son's lasting fame.

Sherman loved the South and did not oppose slavery, but he was a Union man to the core. Tentative about command at first, Sherman did well. Lincoln liked what he saw in him and promoted Sherman to a rank higher than his future commander, Grant. His star rose—then burned out. Sherman fell into a depression. The press harped on him, declaring him "insane." After being forced to take leave, he returned and lobbied for a post with Grant.

Sherman got his wish. At Shiloh he recovered his reputation, shining under Grant's leadership. A master of logistics, Sherman showed that he could get the big jobs done. In 1864, he hit the South at its heart, capturing the key city of Atlanta. He promised Grant that he could "make Georgia howl" and led his army on a "March to the Sea." The daring move shortened the war, saving countless lives. Sherman's bold capture of Savannah also helped Lincoln win re-election.

By war's end, Sherman was the second highest ranking man in the Union Army—and later held the post of Commanding General of the United States.

WILLIAM TECUMSEH SHERMAN
1820-1891

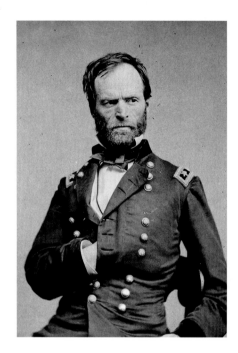

Born
* Lancaster, Ohio

Claim to fame
* The March to the Sea, capture of Savannah, burning of Atlanta

Education
* U.S. Military Academy at West Point (6/43 in his class—should have been fourth but had too many demerits for discipline and infraction of the dress code)

Nicknames
* Attila of the West, Crazy (seen talking to himself, Cincinnati Hotel, early war), Cump/Cumpy, Old Pills, Old Sugar Coated, Tecumseh the Great, Uncle Billy (his soldiers)

Horse(s)
* Lexington (favorite), a famous Kentucky racehorse; Dolly; and Sam. Cincinnati, Grant's horse, was Lexington's son and a gift from Sherman to Grant

Family
* Eleanor (Ellie) Ewing, married 1850, President Zachary Taylor attended his wedding
* Eight children: four sons, four daughters (two sons died in childhood during the war)

Personal characteristics
* Reddish, rumpled hair

Personal trivia
* Good at math, drawing and chemistry at West Point
* Stepfather sat on Ohio Supreme Court
* Stepbrother Thomas Ewing Jr. served as defense counsel for the Lincoln conspirators in military trials
* Brother was U.S. Senator John Sherman
* Before the Civil War, became a banker in San Francisco
* Tried being a lawyer; lost his only case
* Loved the South. Became superintendent of Louisiana Seminary Academy (today's Louisiana State University) two years before the war
* One of first jobs in military: completed survey of Sacramento, California
* Distantly related to Roger Sherman, signer of the Declaration of Independence
* Son became a Catholic priest
* One of his granddaughters married the grandson of famed Confederate General Lewis Armistead
* A giant Sequoia tree in Sequoia & Kings Canyon National Parks was named for him in his lifetime; according to the National Park Service, it is the largest tree (by volume) in the world at just under 275 feet tall, 52,508 cubic feet in volume, and is 1,800–2,700 years old
* Post-war hobbies: going to the theater, dancing at balls (according to Ulysses Grant)
* Loved his Ohio hometown but it bored him; he moved to New York City after the war and died there
* Died in New York City on Valentine's Day, 1891

LEFT / Sherman and son Thomas, c. 1860s. Thomas became a priest—to his father's consternation. He presided over his father's funeral in 1891 and served as an Army chaplain during the Spanish-American War. *Notre Dame Archives, William T. Sherman Family Papers*

BOTTOM LEFT / Sherman's wife, Eleanor "Ellie" Boyle Ewing Sherman, photograph of a painting by GPA Healey, Chicago, 1869. Sherman survived her by three years. *Notre Dame Archives, William T. Sherman Family Papers*

BOTTOM RIGHT / Several of their children. *Notre Dame Archives, William T. Sherman Family Papers*

Entered, according to Act of Congress, in the year 1865, by J. CARBUTT, in the Clerk's Office of the District Court of the United States for the Northern District of Illinois.

Head Qrs. 15 Army Corps.
Camp on Bear Creek. July 4. 1863.
Maj Genl Grant.

My Dear General.

The telegraph has just announced to me that Vicksburg is ours. its garrison will march out, stack arms & return within their lines as Prisoners of War. and that you will occupy the City only with such troops as you have designated in Order. I can hardly contain myself. Surely will I not permit any soldier for being "brave & happy" this most Glorious anniversary of the birth of a Nation whose sire & Father was a Washington. Did I not know the honesty, modesty & purity of your nature I would be tempted to follow the example of my standard literature of the Russ in indulging in wanton flattery. but as a man & soldier and ardent friend of yours I warn you against the incense of flattery that will fire one [...] from one extreme to the other. Be yourself and yourself. and this glittering flattery will be as the passing breeze of the Sea of a warm summer day. To me the decision with which you have treated a brave but deluded enemy, is more eloquent than the most gorgeous oratory of our [...].

This is a day of Jubilee. a day of rejoicing to the faithful. and I would like to hear the cheers of my old spartan troops. but I must be a Good general. I must have facts. knowledge. and must go on. Already am my orders out to give one big hurrah. and sling the Knapsack for new fields. [...] will march as one to Messengers. Ranks to Brisburg and I will shift my Head Quarters to Fox. McArthur will clear the Road of obstructions made against the coming of the enemies Johnston and as soon as Ord & Steeles Columns are out I will push ahead. I want maps. but of Course the first thing is to clear Black River and get up on the high ground beyond. When on more according to developments. I did want Rest. but I ask nothing till the Mississippi River is ours. and Sunday and Fourth of July are nothing to Americans till the River of our Greatness is free as God made it.

Though in the back ground as I ever wish to be in Civil war. I see that I have contributed some to hasten this Glorious Result.

I am with respect
Your friend.
W. T. Sherman
Maj Genl Comdg.

REGULATIONS

FOR THE

ARMY OF THE UNITED STATES,

1857.

NEW YORK:
HARPER & BROTHERS, PUBLISHERS,
FRANKLIN SQUARE.

GLC 08398

ABOVE / *By the book*

Sherman used this copy of the U.S. Army's *Regulations, 1857,* while superintendent of the Louisiana State Seminary of Learning and Military Academy—the forerunner of today's Louisiana State University. *On loan from the Gilder Lehrman Institute of American History*

LEFT / *The next fight*

Sherman wrote this letter congratulating Grant on his July 4, 1863, victory at Vicksburg. It shows Sherman's relentless nature to push on to the next fight: "Already are my orders out to give one big huzza, and sling the Knapsack for new fields…I ask nothing till the Mississippi River is ours, and Sunday and Fourth of July are nothing to Americans till the River of Greatness is Free as God made it." *On loan from the Gilder Lehrman Institute of American History*

451

Muldraughs Hills
Sept 20. 1861

Hon Thos Ewing

Events may transpire which much
affect the personally very much of which you
are more competent to judge than any other.
I never did like to serve with volunteers, because
instead of big ground they govern, and on the
principle that the King can do no wrong. So
they can do no wrong, and any misadventure
is charged on the officer. But fate will allow no
man a choice and he must perforce drift with
the Current of events. I happened in Louisville
when the Secessionists cut the Telegraph wire on the
Nashville Road, and seized many cars. The
report was very indefinite. At the time there
were in Louisville only Home Guards to the number
of about 1200. composed of young men. Such as
make up our volunteer Companies. There was
also a Regiment of so called Kentucky troops
across the River from Louisville, with two incom-
plete Regiments under a Kentucky Lawyer
named Rousseau. upon consultation Genl
Anderson ordered me to take such of the Home
Guards as could be hastily collected together
and the Men of Rousseau, and proceed on
the Cars as far as possible. Rocky, there

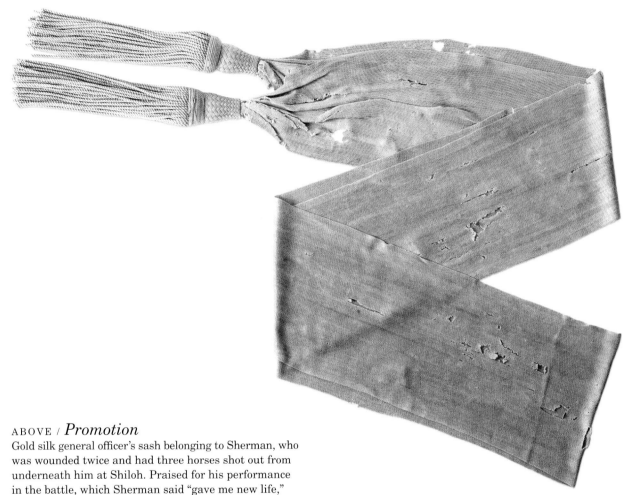

ABOVE / *Promotion*

Gold silk general officer's sash belonging to Sherman, who was wounded twice and had three horses shot out from underneath him at Shiloh. Praised for his performance in the battle, which Sherman said "gave me new life," he received promotion to major general several weeks after that battle on May 1, 1862. *On loan from the Civil War Museum of Philadelphia*

LEFT / *Dire consequences*

Writing to friend Philemon Ewing on September 30, 1861, Sherman complains about undisciplined volunteer soldiers: "The Volunteers also in compliance with their unbridled will are killing hogs, cattle, burning fence rails, and taking hay and wheat, all calculated to turn the People against us. [The enemy] are all imbued with a bitterness that you cannot comprehend and will jump at the chance to destroy us whom they now regard as Northern hordes of Invaders." *On loan from the Gilder Lehrman Institute of American History*

GLC 01203

ABOVE / *Private reservations*

Written to his stepfather, Thomas Ewing, this May 3, 1862, letter from Sherman recounts his experience at Shiloh, where his bold performance helped restore his reputation as an aggressive, effective commander. He also expressed some doubt about Grant, calling him "very brave but not brilliant." *On loan from the Gilder Lehrman Institute of American History*

RIGHT / *A long war*

Although this letter from Sherman on September 9, 1861, primarily concerns details about getting a West Point appointment for the recipient's brother, it contains Sherman's stunning prediction about the length of the war. He was one of few who accurately foretold a long struggle: "We are in for a long & bloody Civil War, the end of which no Man Can foresee—" *On loan from the Gilder Lehrman Institute of American History*

the Ruling Room — India within a few
days. I commanded a Brigade in Virginia
was one of the defeated at Bull Run —
but am now here to help General Robert
Anderson in Kentucky. Strange to say, the
fate of that State is undecided — at all
Elections the Union party wins, but the
Rebels seem to attach little importance
to Elections. The Southerns care little
about popular Majorities and thus far
have managed to despise all such
antiquated formulae. We are in for
a long & bloody Civil war, the end of which
no man can foresee. You are lucky
in being far from the Scene of unnatural
Strife. Present me kindly to any of
my friends near you, and believe me
always most truly,
 Your friend
 W. T. Sherman

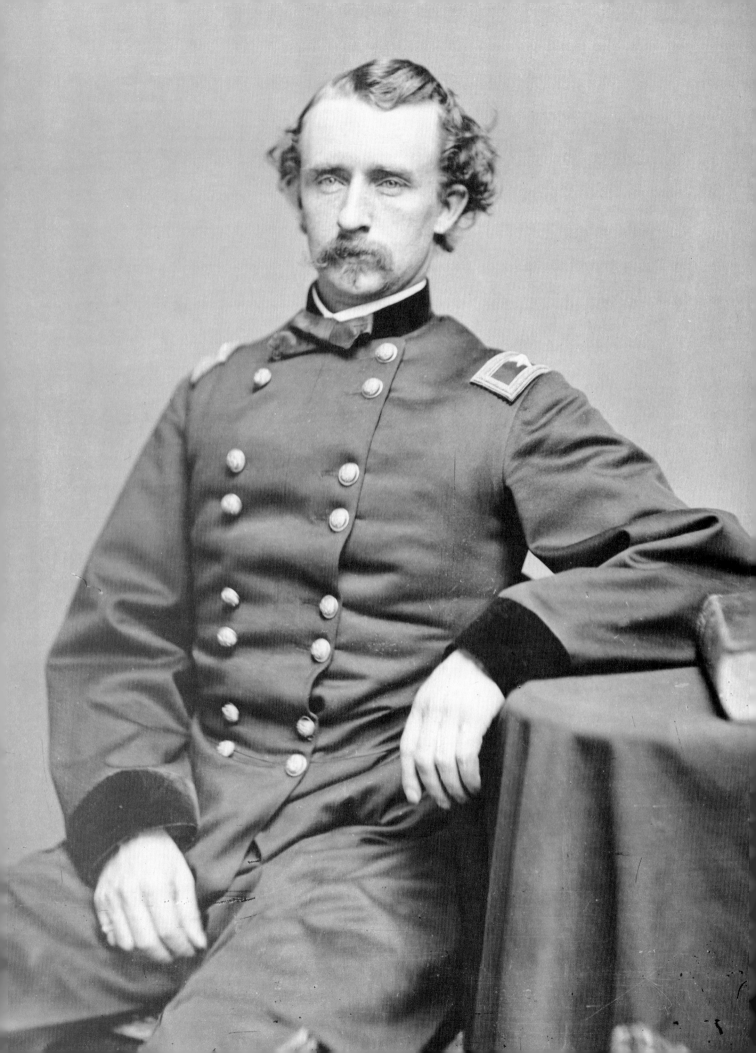

You ask me if I will not be glad when the last battle is fought, so far as the country is concerned. I, of course, must wish for peace…but if I answer for myself alone, I must say that I shall regret to see the war end.

—George Armstrong Custer

GEORGE ARMSTRONG CUSTER
1839–1876
Union Cavalry General

He's far more famous for his fate at Little Bighorn, but the beginning of George Custer's reputation for courage and cunning had its roots in the Civil War.

Even though last in his West Point class, Custer got lucky when war broke out; the Union Army needed all the officers it could get. He became a lieutenant with the 2nd U.S. Cavalry. A showman with the saber, Custer's daring attracted the attention of army commander George McClellan, who appointed him to his staff. McClellan's cavalry chief saw Custer's potential and recommended him for promotion. At age 23, days before Gettysburg, he became one of the youngest brigadier generals in the Union Army.

The Union cavalry struggled early in the war, but later came into its own—and Custer played a large role in its development. In the 1864 Shenandoah Valley Campaign, Custer and the Union cavalry sometimes clashed with Confederate forces led by partisan ranger John Mosby. Strategic warfare turned to brutality: at one point, both forces executed each other's prisoners. By April 1865, Custer helped tighten the noose around Confederate forces, triggering Lee's surrender.

After the war, Custer—a national celebrity—remained with the army. Assigned out west as part of the U.S. effort to push Native Americans onto reservations, Custer's luck ran out in June 1876 when he and part of his command were killed at the Little Bighorn.

GEORGE ARMSTRONG CUSTER
1839–1876

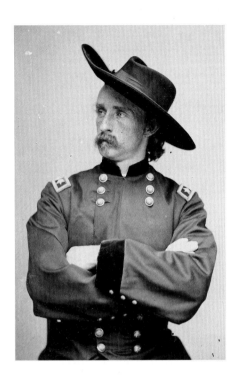

Born
- New Rumley, Ohio

Claim to fame
- One of the youngest brigadier generals in Union Army
- "Custer's Last Stand"—massacred with his troopers at the Little Bighorn

Education
- U.S. Military Academy at West Point (last in class)

Nicknames
- Boy General; Curly, Fanny (about his hair); Autie—his childhood pronunciation of Armstrong; Cinnamon
- During Indian wars: Hard Ass and Iron Butt for physical stamina in saddle; "Ringlets" for vanity (his hair)

Horse(s) in Civil War
- Lancer (favorite), Roanoke, Harry, Don Juan

Family
- Wife, Elizabeth Bacon
- No children

Personal characteristics
- About 6 feet tall, broad-shouldered, slim waist, muscular legs
- Wore his hair in long, shiny ringlets sprinkled with cinnamon-scented oils (he curled his hair around candles while he slept)

Personal trivia
- So poor that he and a classmate carried coal to pay their room and board
- Known for his pranks and demerits at West Point
- A fashionista (one soldier said he looked like a "circus barker")
- Had more photographs taken of himself than any other Union general during the war
- Always wanted to be a soldier
- Horse shot out from under him 11 times throughout the war
- Wore red cravats (form of necktie) into battle
- Met his future wife at age 10. Did odd jobs for future wife's family, but was never allowed in the house.
- Proposed to future wife in 1862, but her father—a prominent Michigan judge—thought he was beneath her social station; didn't consent to their marriage until Custer was promoted to brigadier general, which happened right before Gettysburg
- His wife was one of the few wives of Civil War generals to accompany her husband to the front
- After Custer's death at the Little Bighorn, his wife wrote three bestsellers that bolstered his reputation: "Boots and Saddles," "Tenting on the Plains," and "Following the Guidon." The books were considered accurate for the most part.

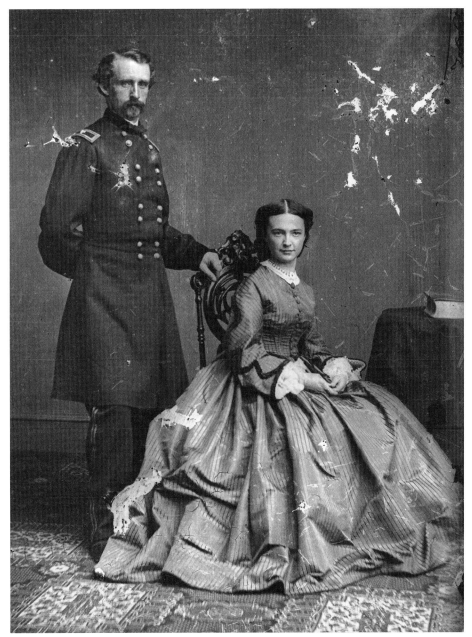

LEFT / Custer and his wife, Elizabeth Bacon Custer, during the war. Well educated, "Libbie" traveled with Custer to the front throughout his career. She outlived him by nearly 60 years.

RIGHT / Custer enjoyed having his photograph taken, alone or with others, as in this likeness with a dog during the Peninsula Campaign in 1862.

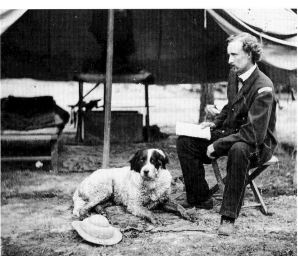

Head Quarters, Army of the Potomac,

1862, / / / o'clock, M.

Col Colburn

We have just
captured one
three inch
gun and its
Caisson on the
road from the
Hagerstown pike to Shep...
town [illegible] Hunt
had better send out for
it, we cannot take it

By command of Major General McClellan:

ABOVE / *Charge!*

Known for his willingness to personally lead charges against the enemy, Custer became one of the youngest brigadier generals in the Union Army at age 23 just before Gettysburg. There he used this silk cavalry guidon featuring crossed sabers on a blue and red field. It conforms to the standards for cavalry flags in the Army of the Potomac. *On loan from the Civil War Museum of Philadelphia*

LEFT / *Man of action*

Written the day after Antietam to Union Col. John Coburn, Custer relays how he captured one three-inch gun and its caisson. Custer was serving as an aide-de-camp on the staff of army commander Maj. Gen. George B. McClellan at the time. *On loan from the Gilder Lehrman Institute of American History*

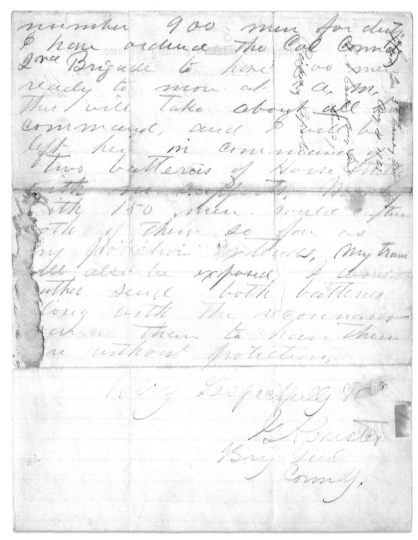

GLC 00614

ABOVE / *Lean and mean*
Custer wrote to Union Army of the Potomac Cavalry
Chief Alfred Pleasonton on August 4, 1863, suggesting
he preferred to relinquish two batteries of horse artillery
attached to him because he believed keeping them made
him vulnerable to the Confederate partisan raider
Col. John S. Mosby. Mosby and Custer parried with
one another the following year in the brutal Shenandoah
Valley Campaign. *On loan from the Gilder Lehrman
Institute of American History*

RIGHT / *Credit where credit is due*
Pattern 1851 wool officer's frock coat worn by Custer.
He enjoyed the rigors of military life and was not shy about
promoting the achievements of himself or those under his
command. "I challenge the annals of warfare to produce
a more brilliant or successful charge of cavalry," he said
about his performance at Gettysburg. *On loan from the
Smithsonian Institution, National Museum of American
History, Kenneth E. Behring Center*

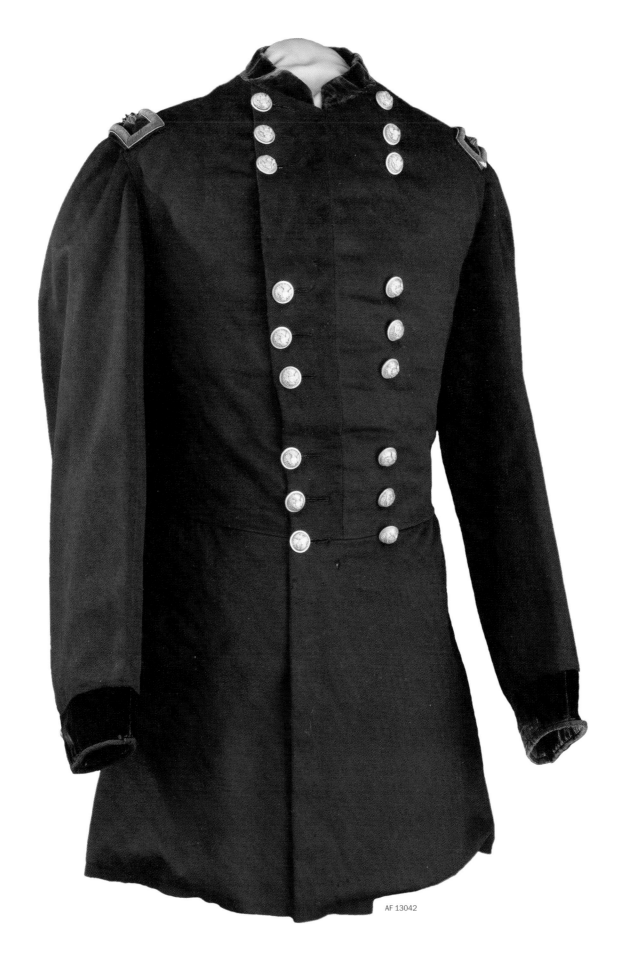

AF 13042

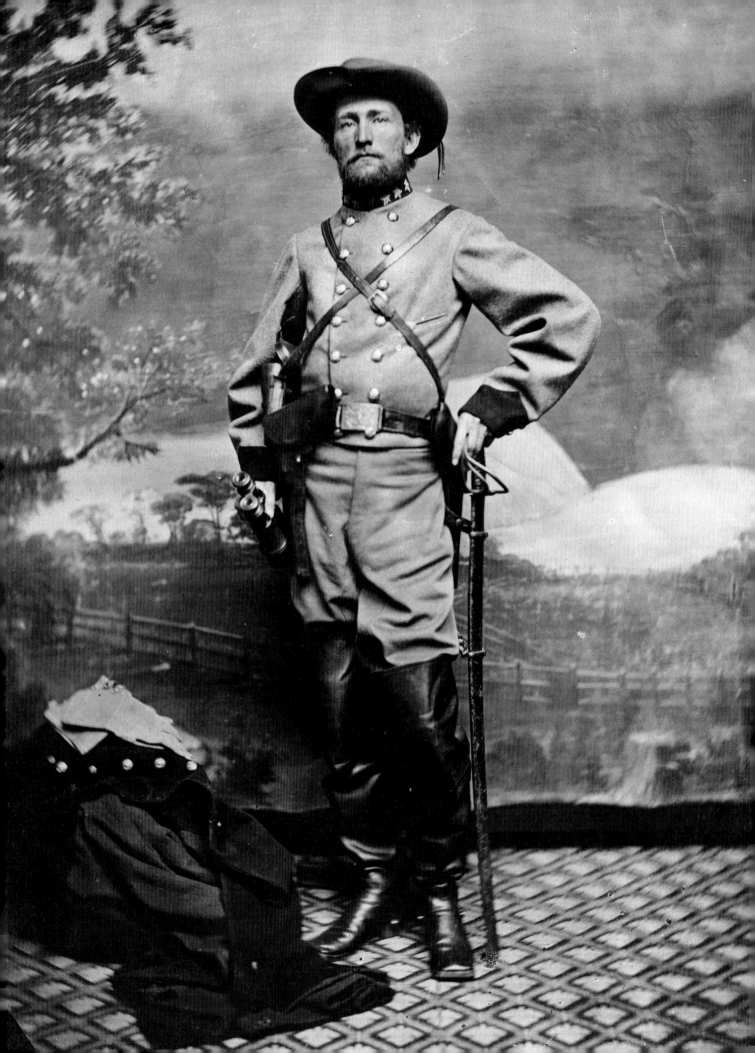

Only three men in the Confederate army knew what I was doing or intended to do; they were Lee and Stuart and myself.

—John Singleton Mosby

JOHN SINGLETON MOSBY
1833–1916
Confederate Cavalry Colonel

A frail boy who racked up a criminal record before he was expelled from college, John Mosby found his stride in life when he joined the Confederate cavalry. Mosby didn't appear suited for the rigors of the saddle. One recruit said, "He did not even strut."

He quickly became known for gathering enemy intelligence— receiving a promotion and earning a place among Confederate cavalry great J.E.B. Stuart's scouts. He helped Stuart devise plans for the famous "Ride around McClellan" in 1862. Mosby's leadership earned him approval to form his own command, the 43rd Virginia Battalion of Cavalry—soon known as "Mosby's Rangers."

He led raids to harass Union troops, steal supplies and slip through enemy lines to capture high-ranking officers. Mosby seemed to disappear into thin air—earning him the nickname "the Gray Ghost." A one man public-relations agency, he even took journalists prisoner, plying them with fine food and cigars to get favorable press coverage.

In the 1864 Shenandoah Valley Campaign, Mosby kept up a furious pace, deflecting Union cavalry and staving off Union incursions. He delayed, for a time, the collapse of the Confederate war effort on this front. After the war, rather than face imprisonment, Mosby disbanded his rangers, returning to his first profession, the law. He joined the Republican Party and worked for Grant's presidential campaign; he also became U.S. consul to Hong Kong.

JOHN SINGLETON MOSBY
1833–1916

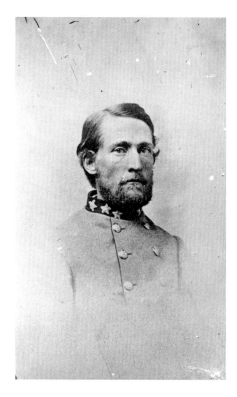

Born
- Edgemont, Virginia

Claim to fame
- Leader of Mosby's Rangers (43rd Battalion Virginia Cavalry)

Education
- University of Virginia (UVA), math, languages, natural philosophy (didn't graduate—expelled for shooting a fellow student)
- Member, UVA's literary and debating society

Nicknames
- Gray Ghost, the Fox of Fauqier, The Scarlet Cloak (Union soldiers), Prince of Guerillas

Personal characteristics
- About 5 feet 7 inches tall, 128 lbs.
- Sandy blond hair, blue eyes
- Chronic lung problems, frail health
- Clean shaven until end of war
- Described as "hatchet-faced" and "hawked-nosed"

Horse in Civil War
- Coquette (favorite), a gift of his men

Family
- Wife, Pauline Clarke
- Eight children: four sons, four daughters

Personal trivia
- Bullied in school ("Boys are the meanest things in the world…the larger ones invariably take advantage of the smaller ones," he said)
- Criminal record: Arrested for assaulting a police officer; convicted and sentenced to prison for shooting a fellow UVA student
- Loved to read Greek literature in college
- Made sauce for peach pie that his soldiers loved
- Future U.S. president Andrew Johnson attended his wedding
- His African-American personal servant from boyhood, Aaron, traveled with him throughout the war
- Had academic books sent to him on the war front to read in "down time"
- Picked his teeth with a twig when deep in thought
- Couldn't sit still for more than 10 minutes
- After the war, moved to California and worked for the Southern Pacific Railroad
- Befriended the father of famed World War II General George S. Patton. Patton's father was a fellow Virginian who owned a home on the Pacific coast. When Mosby visited Patton's father, he also discussed and re-enacted his Civil War exploits with Patton Jr., age 10, on the elder Patton's property—on horseback. Mosby played himself and Patton Jr. played Robert E. Lee.

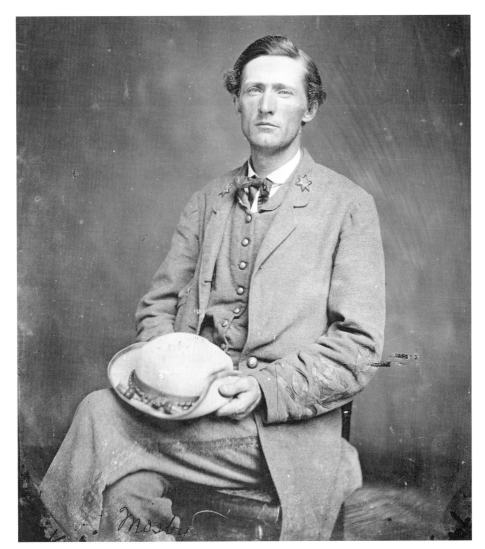

LEFT / A feared Confederate cavalry raider during the war, Mosby was bullied as a child.

RIGHT / Daughter of a former U.S. Congressman and diplomat, Mosby's wife Pauline died after giving birth to their eighth child. Mosby outlived his wife by 40 years but never remarried. *Virginia Historical Society*

Head Quarters of the Army,

Washington D C

October 12th 1864.

Brvt Brig Genl. Mc Callam

Washington D.C.

General.

The Secretary of War directs that in retaliation for the murderous acts of Guerilla bands, composed of, and assisted by the inhabitants along the Manassas Gap Railroad, and as a measure necessary to keep that road in running order, you proceed to destroy every house within five miles of the road, which is not required for our own purposes or which is not occupied by persons known to be friendly. All males suspected of belonging to or assisting the robber bands of Mosby, will be sent under Guard to the Provost Marshal at Washington, to be confined in the Old Capitol Prison. The women and children will be assisted in going north or south as they may select. They will be permitted to carry with them their personal property and such provision as they may require for their own use.

GLC 06725

Forage, animals and grain will be taken for the use of the United States. All timber and brush, within musketry fire of the road, will be cut down and destroyed. Printed notices will be circulated and posted, that any citizen found within five miles of the road hereafter, will be considered as robbers and bushwhackers, and be treated accordingly.

Copies of these instructions will be sent to General Augur and General Sheridan with orders to give you all possible military aid for the accomplishment of these objects.

The inhabitants of the country will be notified, that for any further hostilities committed on this road or its employees, an additional ten miles on each side will be laid waste, and that section of country entirely depopulated.

Very respectfully
your obedt. servt.
H. W. Halleck
M.C. Ch[...]staff

LEFT & ABOVE / *Stop him*
Guerilla warfare in the 1864 Shenandoah Valley Campaign involved fighting near the Manassas Gap railroad line in Virginia. In this October 12, 1864, letter, Union Army Chief of Staff Henry Halleck writes to the Union Superintendent of Railroads Daniel McCallum about the urgency of capturing Mosby. The letter was forwarded to Union General Philip Sheridan as well. *On loan from the Gilder Lehrman Institute of American History*

CWMP 86.20.9

ABOVE / *Close call*
Mosby and his rangers effectively harassed Union forces
in Northern Virginia and the Union wanted him dead or
alive. While galloping at top speed after Mosby during the
war, Captain John M. Locke, 2nd Massachusetts Cavalry,
snagged Mosby's wool scarf—which had blown off during
the pursuit—with the tip of his saber from a roadside
shrub. *On loan from the Civil War Museum of Philadelphia*

RIGHT / *A raider is born*
Jean cloth, woven wool and cotton frock coat belonging
to Mosby based on the Pattern 1851 Army officer's frock
coat. He wrote his wife after the famous "Ride around
McClellan's Army," telling her "I not only helped to execute
it, but was the first one who conceived and demonstrated
that it was practicable…everybody says it is the greatest
feat of the war. I never enjoyed myself so much in my
life." *On loan from the Smithsonian Institution, National
Museum of American History, Kenneth E. Behring Center*

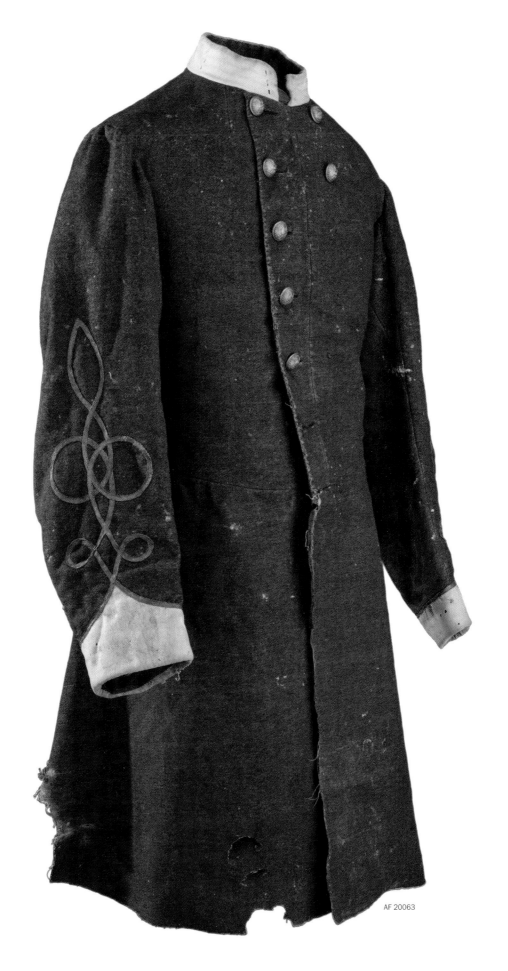

AF 20063

LETTERS

OF

COL. MOSBY AND JOHN TYLER, JR.

[FROM THE NEW YORK HERALD OF AUG. 12, 1876.]

WASHINGTON, August 12, 1876.

The following letter has been written by Colonel Mosby to a former confederate comrade in reply to one urging him to support Tilden:

WARRENTON, VA., August 6, 1876.

MY DEAR SIR:—I have just received your communication inquiring if it be true, as reported, that I am supporting Hayes and Wheeler. It is true that I am a cordial and earnest advocate of the election of that ticket, notwithstanding you say that all the Southern people, and especially the confederate soldiers, are united in support of the Democratic. I hope, however, that in this you are mistaken, and that many men in the South, of sound conservative and national sentiments, will be found on the other side. However this may be, it will not divert me from my purpose. I thought you knew that I ceased to be a Confederate soldier about eleven years ago, and became a citizen of the United States. As a soldier, I did conscientiously what I thought to be my duty; as a citizen, I shall do the same thing as far as I know how. The ground on which you urge me to support Tilden and Hendricks is that they are the candidates of the Southern people, and, if elected, will be under their control. Now, it is because this thing is apparent that the election of Tilden is an impossibility. In attempting to grasp too much the South will lose everything. The sectional unity of the Southern people has been the governing idea and bane of their politics. So far from its being the remedy for anything, it has been the cause of most of the evils they have suffered. So long as it continues, the war will be a controlling element of politics; for any cry in the South that unites the confederates re-echoes through the North, and rekindles the war fires there. Thus, every Presidential canvass becomes a battle between the two sections, and the South being the weaker, must be the losing party. To insist on keeping up this sectional fight may be very heroic—so was the charge at Balaklava—but, in my opinion, is just as reckless and just as unwise. The reconstruction measures necessarily divided parties in the South on a color line, for the issue they presented was the political equality of the races. While the South was opposing it the Republican party was on the side of the negro. But since the South has accepted it, and incorporated it in the platform on which it has mounted its candidate, I see no reason for continuing to divide on an issue which has become extinct. Having adopted all the principles of a party, and sanctioned all its measures, I can see no objection to voting for its candidate. Do you not see, then, that as long as we keep up the fight on the old lines, with the same allies and same battle cries, the North will be suspicious of our good faith, no matter in what form we protest it! All that the Republicans propose is to preserve what they have accomplished. The Democrats are pledged not to disturb what the Republicans have done. You cannot complain that the sincerity of the pledges of Governor Tilden to execute certain laws is distrusted when his supporters justify their opposition to Governor Hayes on the ground that his party has enacted these laws. To be consistent, they should go for repealing them if they come into power. I concur with you in a desire for a change in the policy of the national government towards the South, but that can only come from a change in the attitude of the Southern people towards the administration. You say that no one in the South is supporting Hayes but negroes and carpet baggers. I would be sorry if this were so; but if it were, I should still vote for the candidate of my choice, and would not let this class deprive me of it. I suppose they support Hayes because they think it is to their interest to do so. I think it would be equally to the interest of all the Southern people to do the same thing. But you say that even admitting it were better for them to do so, yet, as it is notorious they will not, that I ought to surrender my individual convictions to the will of the majority. I don't think so. It is better for some to go right than for all to go wrong. If I think they are going wrong I could do no good by going with them. If they are bent on breaking their necks, I don't intend to assist them; neither can I see what good it would do them for me to break mine. Besides,

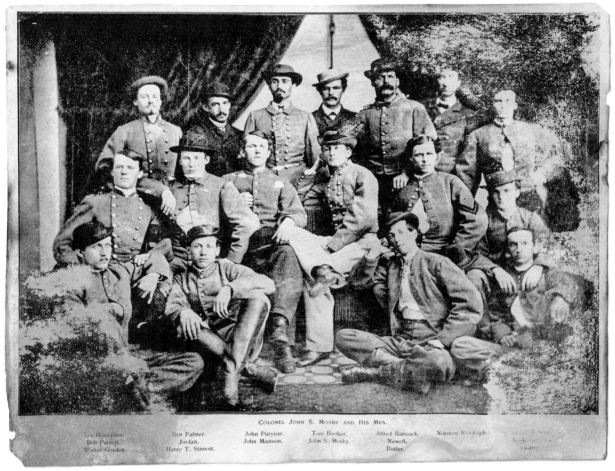

COLONEL JOHN S. MOSBY AND HIS MEN.

Lee Heverson. Ben Palmer. John Puryear. Tom Booker. Alfred Babcock. Norman Randolph.
Bob Parrott. Jordan. John Munson. John S. Mosby. Newell.
Walter Gosden. Harry T. Sinnott. Butler.

ABOVE / *Mosby's Rangers*

Mosby assembled a like-minded team like no other.
He groomed them and measured their success by how
many soldiers in the Union Army were required to keep
tabs on his partisans. "I wanted to use and consume the
Northern cavalry in hard work. I have often thought that
their fierce hostility toward me was more on account of
the sleep I made them lose than the number we killed
or captured." *Gettysburg National Military Park, National
Park Service*

LEFT / *Citizen Mosby*

After the war, Mosby joined the Republican party—the
party of Lincoln. In this August 12, 1876, letter, reprinted
in *The New York Herald*, Mosby tells an acquaintance who
urged him to vote for the Democratic presidential candidate:
"I thought you knew that I ceased to be a Confederate
soldier about eleven years ago, and became a citizen of
the United States." Mosby instead supported Republican
candidate Rutherford B. Hayes, who won the election. *On
loan from the Gilder Lehrman Institute of American History*

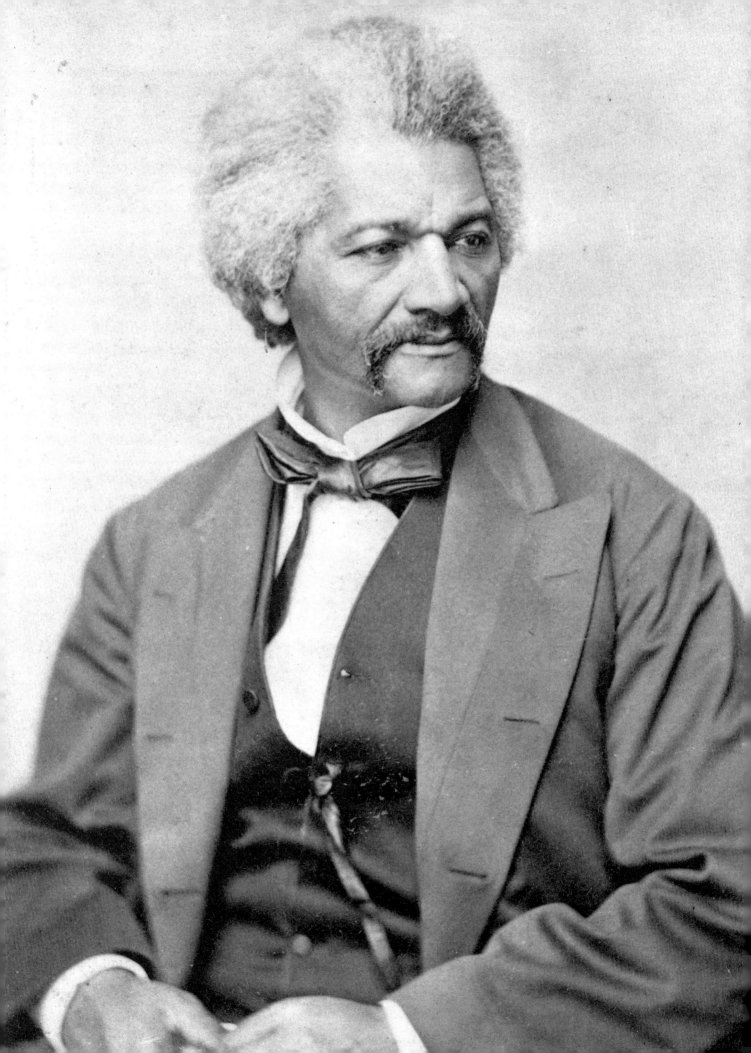

It is not light that we need, but fire; it is not the gentle shower, but thunder. We need the storm, the whirlwind, and the earthquake.

—Frederick Douglass

FREDERICK DOUGLASS
1818–1895
Human-Rights Activist

One of the most photographed Americans of the 19th century, Frederick Douglass climbed out of slavery to become one of the fiercest, most eloquent voices of human-rights reforms. His mastery of the written and spoken word influenced leaders at the highest levels, transforming the war and many Americans' lives.

As a slave, Douglass taught himself to read and write. Impersonating a sailor, he escaped and moved North. Hired for the anti-slavery lecture circuit, Douglass owned the speaker's platform the moment he stepped onto it. A journalist who heard his first speech wrote, "Flinty hearts were pierced, and cold ones melted by his eloquence."

The public was more skeptical. Many did not believe such an articulate man had been a slave—prompting Douglass to write several books about his life as one. He also became a newspaper publisher, putting pen to paper to gain support for his ideas.

Through his oratory, writing and conversations with Lincoln, he redefined the war's purpose. Douglass urged the president to use the war as a springboard to create a new, stronger nation with equality for all citizens. He helped convince Lincoln to allow African Americans to join the Union Army, then helped recruit several all-African-American infantry units. He helped encourage the Emancipation Proclamation. Douglass wrote later: "We fought the rebellion, but not its cause. This proclamation changed everything."

FREDERICK DOUGLASS
1818–1895

Born
• Frederick Augustus Washington Bailey in slave cabin, Eastern Shore, Maryland

Claim to fame
• Former slave who bought his freedom
• Prominent human-rights activist
• Nationally known speaker

Education
• Self-taught; learned alphabet from owner's wife when a slave
• Taught himself to speak several languages
• Howard University, honorary doctorate

Nicknames
• The Lion of Anacostia, the Sage of Anacostia

Family
• First wife, Anna Murray, 44 years, died 1882
• Second wife, Helen Pitts, 1884–1895
• Five children: two girls, three boys with first wife
• Two of his sons served with the 54th Massachusetts Infantry, subject of the Academy-award winning film "Glory"
• 21 grandchildren, including Joseph, renowned concert violinist and first African-American violinist to play on several continents
• Response to criticism that his second wife was Caucasian: first marriage had been to someone the color of his mother, and his second to someone the color of his father

Bestselling author
• "Narrative of the Life of Frederick Douglass," 1844; "My Bondage and My Freedom," 1855; "Life and Times of Frederick Douglass," 1881

Pet
• Frank, his mastiff, who died of grief several weeks after Douglass' death

Personal characteristics
• About 6 feet tall, 200 lbs.
• Known for being kind, courteous, gentle

Personal trivia
• First paid job after escape from slavery: day laborer on the wharf
• Initially called Lincoln the "White Man's President"
• Liked to wear three-piece suits
• Favorite authors: Charles Dickens, William Shakespeare
• Wasn't sure of his exact birthday but celebrated it February 14
• Hated being called "Fred"
• Amateur violinist
• Liked to play checkers
• Gave his grandchildren piggyback rides and let them braid his hair
• Bought his first house in 1877 for $6,700
• In the 1890s, exercised daily lifting two 12-pound dumbbell weights before breakfast

What he did after the war
• Editor of the "New National Era" (later published by two of his sons)
• U.S. Marshal and Recorder of Deeds for Washington, D.C.
• Minister to Haiti
• Presidential Elector-at-Large for New York

LEFT / Douglass working in his library at *Cedar Hill*, his home in the Anacostia section of Washington, D.C., for the last 18 years of his life.

BELOW / Douglass with his second wife, women's rights activist Helen Pitts, right, and her sister Eva, standing. Although abolitionists, Helen's parents opposed the marriage because Douglass had an African-American mother and a Caucasian father.

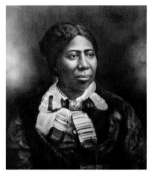

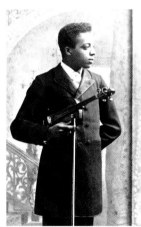

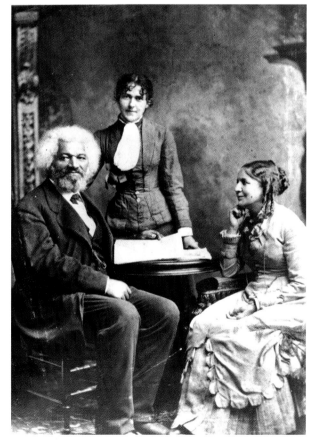

ABOVE / Douglass' first wife Anna Murray. She helped Douglass escape from slavery.

ABOVE RIGHT / Grandson Joseph, renowned concert violinist.

RIGHT / Eldest child Rosetta, who worked on her father's newspapers.

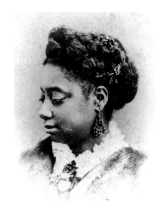

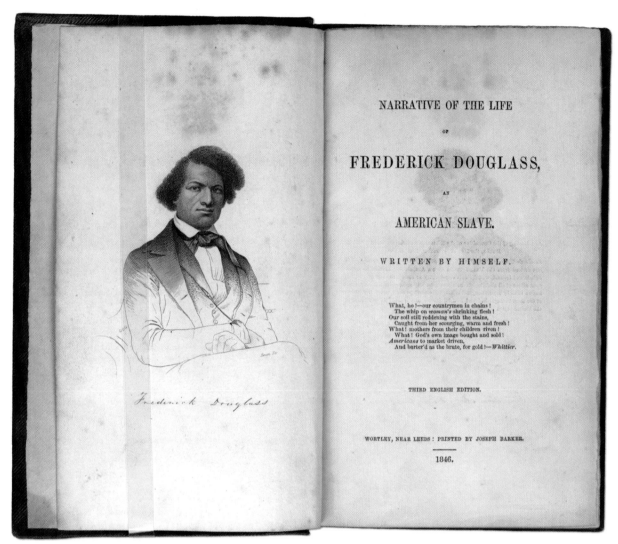

GLC 05117

ABOVE / *Proof in writing*
Douglass wrote his first autobiography—*The Narrative of the Life of Frederick Douglass, An American Slave*—in 1844 to prove to skeptics that the powerful orator indeed had been a slave. The book became a bestseller. Douglass wrote two more autobiographies about his experiences. *On loan from the Gilder Lehrman Institute of American History*

RIGHT / *To arms!*
Douglass published his own newspapers like this February 17, 1860, edition, to spread his views on human rights to as many Americans as possible. He used publications to recruit African Americans to join the Union Army, writing in the language of the time: "A war undertaken and brazenly carried on for the perpetual enslavement of colored men, calls logically and loudly for colored men to help suppress it." *On loan from the Gilder Lehrman Institute of American History*

Frederick Douglass' Paper.

DEVOTED TO THE RIGHTS OF ALL MANKIND, WITHOUT DISTINCTION OF COLOR, CLASS, OR CLIME.

VOL. XIII.---NO. 9. ROCHESTER, N.Y., FEBRUARY 17, 1860. WHOLE NO. 633.

FREDERICK DOUGLASS' PAPER
IS PUBLISHED EVERY FRIDAY MORNING,
At No. 25, Buffalo Street, opposite the
Arcade,) Rochester N.Y.

TERMS OF SUBSCRIPTION.

An Original Story.

THE STRUGGLE FOR FREEDOM;
A STORY OF INSURRECTION IN VIRGINIA.

CHAPTER I.—[continued.]

CHAPTER II.

GREAT ANTI-SLAVERY MEETING IN WAKEFIELD.

[From the Wakefield (Eng.) Express, Jan. 14.]

[TO BE CONTINUED.]

[CONTINUED ON FOURTH PAGE.]

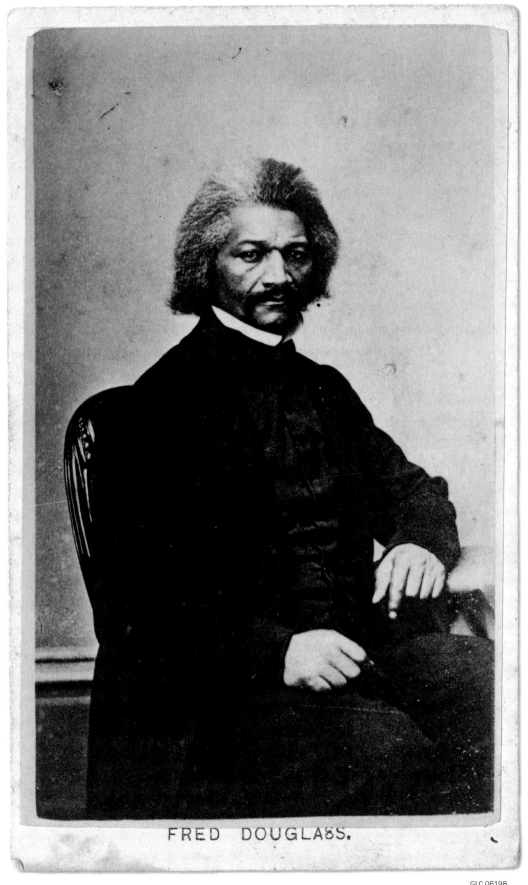

FRED DOUGLASS.

GLC 07484.05

ABOVE / *Freedom bought*
This December 14, 1846, document records the $25 fee
collected by attorney J. Meredith from Douglass' former
owner for handling Douglass' manumission—or legal
process of freeing a slave. *On loan from the Gilder
Lehrman Institute of American History*

RIGHT / *Forgiveness and freedom*
Twenty years after escaping from slavery, Douglass wrote
remarkably to his former owner Hugh Auld: "I feel nothing
but kindness for you all—I love you, but hate slavery." *On
loan from the Gilder Lehrman Institute of American History*

Rochester Oct. 4th (1857

Hugh Auld Esq
 My dear Sir.
 My heart tells me that
you are too noble to treat with indifference the
request I am about to make, It is twenty years
Since I ranaway from you, or rather not from you
but from Slavery, and since then I have often felt
a Strong desire to hold a little correspondence with you
and to learn something of the position and prospects
of your dear children — They were dear to me — and
are still — indeed I feel nothing but kindness for
you all — I love you, but hate Slavery, Now my
dear Sir, will you favor me by dropping me a line, telling
me in what year I came to live with you in Aliceanna st
the year the Frigate was built by Mr. Beacham —
The information is not for publication — and shall
not be published — We are all hastening where all
distinctions are ended, kindness to the humblest will
not be unrewarded
Perhaps you have heard that I have seen Miss Amanda
that was, Mrs Sears that is, and was treated kindly
Such is the fact, Gladly would I see you and Mrs.
Auld — or Miss Sopha as I used to call her.
I could have lived with you during life in freedom
though I ranaway from you so uncerimoniously,
I did not know how soon I might be sold. But I hate
to talk about that. A line from you will find me Addressed Fredk Douglass
Rochester N. York. I am dear Sir very truly yours, Fred: Douglass

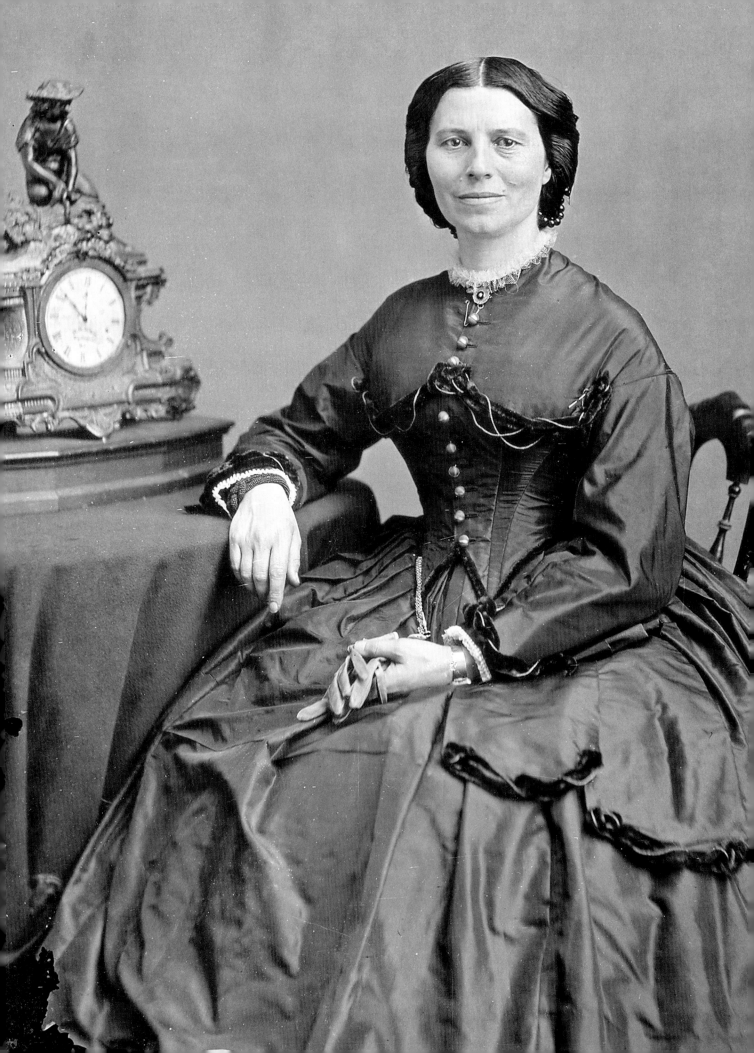

It irritates me to be told how things always have been done…I defy the tyranny of precedent. I cannot afford the luxury of a closed mind. I go for anything new that might improve the past.

—Clara Barton

CLARA BARTON
1821–1912
Founder, American Red Cross

"I'm a United States soldier," Clara Barton told those who questioned a woman's authority to provide supplies and care to wounded soldiers right on the battlefield. Not content to stay behind the lines in hospitals in Washington, D.C., Barton organized provisions, found patrons to buy them and created ways to get them to "her boys"—often beating military medical teams to the front.

Barton held no formal title or role to accomplish her work—she saw suffering and sought to ease it. She worked outside of the system, offending many but also winning the respect of military and political leaders, as well as surgeons—one of whom named her the "Angel of the Battlefield."

Her fame spread fastest among wounded soldiers and their families. Because she stayed close to the war front, those on the home front pleaded with her to help find missing soldiers. Her leadership led President Lincoln to charge her with establishing a formal Missing Soldiers Bureau. Within four years, she identified 22,000 soldiers, giving closure to families nationwide.

She identified 13,000 Union soldiers who died at Andersonville Prison, including creating a tribute to 400 unknowns. When she completed her work there, Barton said, "I ought to be satisfied." She wasn't. Barton served wounded soldiers in two more wars, then founded and organized the American Red Cross.

CLARA BARTON
1821–1912

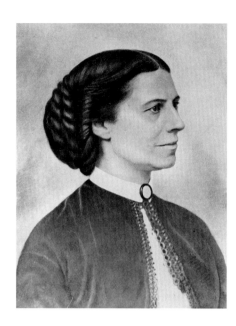

Born
- Oxford, Massachusetts

Claim to fame
- Transformed battlefield medicine
- Director, Missing Soldiers Bureau
- Founder, American Red Cross

Education
- High school, self-taught

Nicknames
- Tot, Tabatha, Miss Barton, Angel of the Battlefield

Family
- Parents, two sisters, two brothers

Favorite foods
- Only ate two meals a day
- For breakfast, graham mush with milk and fruit or meal grains and vegetables
- Other favorite meal: bread, cheese and a Rhode Island Greening Apple

Favorite entertainment
- At home, liked to sit on the porch with family and friends, play cards/board games, sing, play piano, charades, dancing, sewing, painting/drawing
- Participated in church groups; attended theater and sporting/musical events

Pet
- Tommy the Cat, her "faithful friend" of 17 years. His portrait was painted as a gift by the artist Antoinette Margot, who served as Barton's translator during the Franco-Prussian War and worked with her at the American Red Cross.

Personal trivia
- Father served under U.S. General "Mad" Anthony Wayne in the Revolutionary War
- Born on Christmas Day
- Full name: Clarissa Harlowe Barton. Named for her aunt, who was in turn named for Clarissa Harlowe, the heroine of the 1748 bestselling novel of the same name by Samuel Richardson.
- Mother Sarah taught her that women should have the same rights as men; also taught Clara and her sisters how to do what then was considered "men's work," such as chopping wood, to prepare them for life
- Athletic and strong as a child—liked ice skating, chasing snakes, exploring caves, climbing trees
- At age 11, she nursed her brother for two years after he fell from a barn roof and sustained major injuries
- Civil War soldiers named daughters after her
- Believed American Red Cross should also provide relief for disasters during times of peace
- At age 67, she and five Red Cross volunteers arrived in Johnstown, Pennsylvania, just five days after one of the largest floods in American history killed more than 2,200. She stayed for five months to help.
- Corresponded with the founder of modern nursing, Florence Nightingale, but never met her

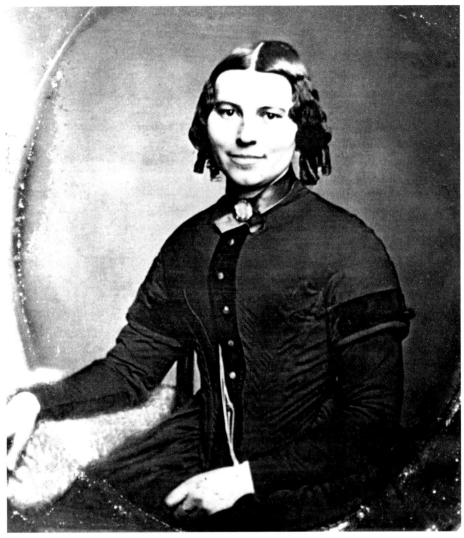

LEFT / Barton at 29, 1850. At first a teacher, she founded a free public school. Its attendance soared—but the community replaced her with a male principal at twice her salary. "I may sometimes be willing to teach for nothing, but if paid at all, I shall never do a man's work for less than a man's pay," she said.

BELOW / David Barton, Clara's older brother. He taught her to ride horses and later became an assistant quartermaster in the Union Army.

ABOVE / Oil painting of Barton's cat Tommy, her favorite pet. An animal lover, she had many pets—from her first dog, Button, to birds and many other cats.

CLBA 3

ABOVE / *Not forgotten*
This 1865 ledger contains details about correspondence
Barton kept with friends of paroled prisoners. The effort
physically exhausted her. When she officially closed the
Missing Soldiers Office in 1869, her doctor advised travel
to Europe to regain her health. While visiting Switzerland,
she learned about the International Red Cross for the first
time. *On loan from Clara Barton National Historic Site,
National Park Service*

RIGHT / *Angel of the Battlefield*
Signed carte-de-visite of Barton at about 54 years old,
ca. 1875. She served as "Angel of the Battlefield" for three
wars—including the American Civil War and Franco-
Prussian and Spanish-American wars. *On loan from
the Gilder Lehrman Institute of American History*

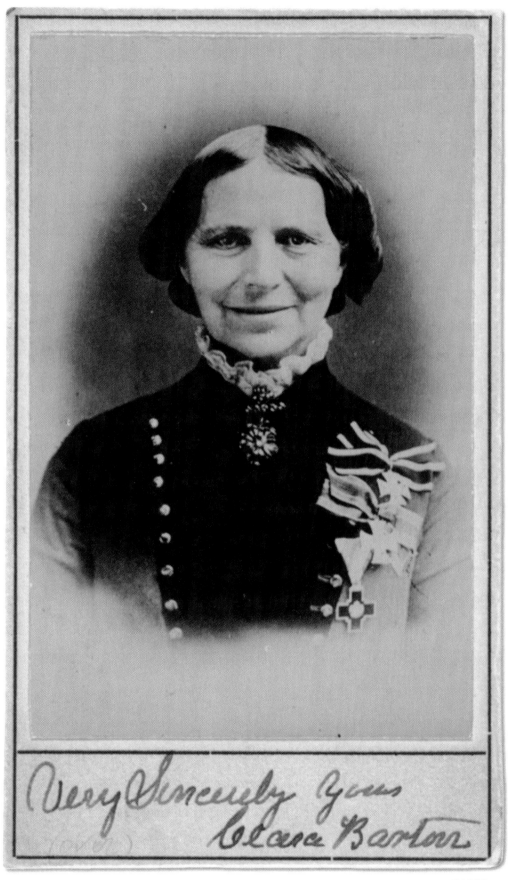

Very Sincerely Yours
Clara Barton

CLBA 2

ABOVE / *Needle in a haystack*

For four years after the war, Barton responded to more than 60,000 requests from Americans searching for information about loved ones still missing from the war. This volume contains names, addresses and the circumstances of the deaths of Civil War soldiers. Through her efforts, Barton ultimately was able to give closure to families of 22,000 soldiers. *On loan from Clara Barton National Historic Site, National Park Service*

RIGHT / *Congressional approval*

After Barton lost her job at the U.S. Patent Office, she struggled to make ends meet while continuing her search for missing soldiers. As detailed in these documents, Congress appropriated $15,000 to reimburse Barton for her expenses and to help fund her efforts to find missing soldiers through 1869. *On loan from Clara Barton National Historic Site, National Park Service*

IN THE SENATE OF THE UNITED STATES.

MARCH 2, 1866.—Ordered to be printed.

Mr. WILSON made the following

REPORT.

(To accompany joint resolution S. No. 36.)

The Committee on Military Affairs and the Militia, to whom was referred the memorial of Miss Clara Barton, praying aid to carry out a plan she has originated for obtaining information of missing soldiers, and communicating the same to their relatives, having had the subject under consideration, beg respectfully to report:

That on the arrival at Annapolis of large numbers of paroled and exchanged prisoners of war, in the winter of 1864–'65, she received letters of inquiry from all parts of the country desiring information of soldiers supposed to have been captured.

She then advertised, with the entire approval of President Lincoln, that she would receive and answer such letters from Annapolis, and by publication of the names of missing soldiers, and personal inquiry among the prisoners, she received information of more than a thousand of the fifteen hundred soldiers whose names were thus published, and which she communicated without delay to their anxious relatives.

She subsequently found it necessary, on account of the largely increased number of inquiries, to extend her labors and incur additional expense, by the employment of clerks and the publication of additional lists of missing men, twenty thousand of which were distributed through the country, including one copy to each post office in the loyal States.

The system which she has originated has thus far proved a complete success, but she has been compelled to abandon the project solely for the lack of means to carry it on; and, in order to enable her to carry it to completion, the committee respectfully recommend the passage of the accompanying joint resolution, appropriating fifteen thousand dollars to reimburse her for expense already incurred, and to aid her in completing her work. The only aid she has heretofore received has been the printing of the rolls by the public printer, which the joint resolution recommends shall be continued.

She has in many instances obtained information of soldiers who were reported "deserters," while they were languishing in southern prisons, and their families were mourning for them as disgraced, and her report has carried joy to many a household, whose members, while they may have had *presumptive* evidence of the capture or death of the absent one, only received positive evidence through her instrumentality. Her observation warrants her in stating that, if the desired aid be granted, information can be obtained of probably four-fifths of those whose fate will otherwise never be ascertained.

The committee therefore respectfully recommend the passage of the accompanying joint resolution.

They are well now, — Mrs. Parks is still with them, — I attended Mrs. Lincoln's levee, a rather reception last Tuesday she was looking remarkably well, but the Pres. grows more gaunt. pale. and care worn than ever, I feel badly when I think how much you have changed him. I do not want to think that he could not endure another four years of toil, and care like the last, and yet it would seem doubtful when one looks at him, I know he is wiry and recuperative, wears like steel, still steel will wear out, and I do not know but he may at last — hope not till his work is done —

They say that the Army of the Potomac is moving a little, but I do not think it can get far at this season. although if this weather holds the spring campaign will commence very early.

Capt. writes me that Lean has left him, and Columbus wrote me that her daughter had been sick, has gone to St Helena I wonder, I thought she feared the Small Pox. — I hope she did not get tired of working for the Capt — did she. I should not wonder in so small a space. I wonder where my things were put, — It seems to me that by some means the Capt will get back his old duties again, but I dont know how — I have a presentiment ‼

What will be done at Fla. now. after this repulse. will our forces remain, or will they draw back to Hilton Head. I sometimes think that the Dept will be broken up save the Blockade, and then that would not seem well but it is unfortunate, and always has been. — Is Genl Gillmore confirmed yet I wonder.

Mr Brown desired to be remembered to you most kindly when I should write — he is still in charge of the Loyal League Rooms, and I think his friends desire him to take or have a position in the Dept of the Interior also — Mrs B is still here with him — she is a fine woman. —

Do you remember that I brought home some little bunches of

the dark. feathery grass. — not supposing that it would last to get here with a spray on it - well it is beautiful come to get it here. every one admires it — and I am only sorry that I could not have known last summer that it would come so well — I should have sent home a while box of it to my own address. it's one of the prettiest things in my room —

Did I tell you that I had Col Leggett's picture framed? you know how nicely you picked it — not a scratch or bend in on it. and I have put it in a nice frame and it is really beautiful. you will say so when you see it — I wonder when that will be? Surgn Genl Hammond is still under arrest and undergoing Court Martial. I cannot learn with what prospects. Where Mrs Sorrel at Hilton Head? Have you a copy of the "South" containing an acct of the repulse, and names of killed & wounded &c — I should like one, but no matter if you have none — I have written you in quite haste Stealing time from company — but you must expect little from me and not be disappointed or to write more if I have time Yrs affly Clara

GLC 08375

CBC O.S.0108

CBC P.0520

ABOVE / *Recordkeeping*
Located on 7th Street NW in Washington, D.C., Clara
Barton's Missing Soldiers Office was rediscovered by
a carpenter in 1996 when an old building was slated
for demolition. This albata pen box was recovered
from the site. *On loan from the U.S. General Services
Administration, Public Buildings Service*

LEFT / *The heat was on*
A palm fan, recovered from the Washington, D.C., office
of Clara Barton. *On loan from the U.S. General Services
Administration, Public Buildings Service*

CBC T.0179

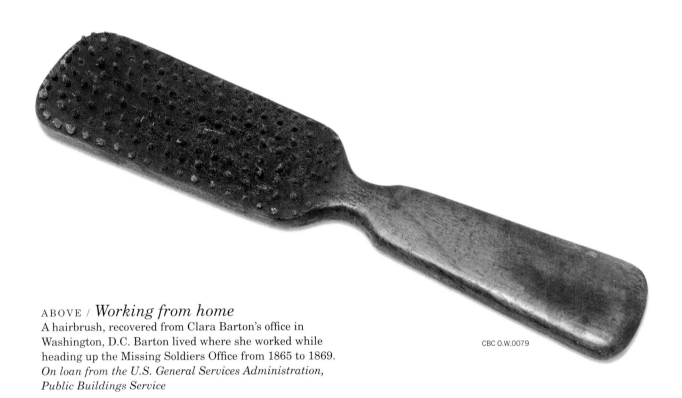

CBC O.W.0079

ABOVE / *Working from home*
A hairbrush, recovered from Clara Barton's office in
Washington, D.C. Barton lived where she worked while
heading up the Missing Soldiers Office from 1865 to 1869.
*On loan from the U.S. General Services Administration,
Public Buildings Service*

LEFT / *Simple comforts*
Sock recovered from Barton's Missing Soldiers Office in
Washington, D.C. Fellow civil-rights activist Francis Gage
said of Barton's efforts: "[While Clara Barton lives and
can work,] she will not forget the widow in her affliction,
or let the fatherless ask in vain, or disappoint the mother's
hope." *On loan from the U.S. General Services
Administration, Public Buildings Service*

Gettysburg National Military Park and the Gettysburg Foundation express profound appreciation for the following institutions that contributed artifacts to *Treasures of the Civil War*:

Civil War Museum of Philadelphia

Gilder Lehrman Institute of American History

The Craig Bashein Collection

National Park Service

 Arlington House, The Robert E. Lee Memorial

 Clara Barton National Historic Site

 Frederick Douglass National Historic Site

 Gettysburg National Military Park

Smithsonian Institution, National Museum of American History, Kenneth E. Behring Center

U.S. General Services Administration, Public Buildings Service

The Civil War Museum of Philadelphia Collection

The Civil War Museum of Philadelphia has one of the most significant collections of Civil War artifacts in the country. It includes over 3,000 artifacts, several thousand photographs, hundreds of works of art, scores of maps and charts, and a most impressive flag collection. The collection ranks among the most comprehensive in the nation with more than 90 percent of the materials having been donated by Civil War veterans, or their descendants who belonged to the founding organization, the Military Order of the Loyal Legion of the United States.

The firearms, edged weapons, and ammunition; uniforms, field equipment and utensils; battle and regimental flags; recruiting posters and commissions; badges and insignia; escutcheons (military coats of arms); surgical tools; band instruments; and other souvenirs from battlefields and prisoner of war camps make a powerful connection to the Union officers who owned them and to their sacrifices at Gettysburg and elsewhere.

The Civil War Museum was chartered in 1888 to formalize a collection that had its beginnings as the Civil War ended in 1865. The Museum was housed in Philadelphia from 1922 until 2008, when it closed in anticipation of building a new museum. With the 150th Anniversary of the Civil War approaching, the Museum Board sought a collaboration with the Gettysburg Foundation and the National Park Service because of their expertise in state-of-the-art care for artifacts and the commitment to creating exhibits that would interpret these treasures in meaningful ways. The Gettysburg Foundation and the National Park Service staff responded with enthusiasm to the opportunity to bring the collection to the Gettysburg National Military Park Museum and Visitor Center.

The Gilder Lehrman Institute of American History Collection is a unique archive of primary sources in American history. Located at the New-York Historical Society, the Collection includes more than 60,000 letters, diaries, maps, pamphlets, printed books, newspapers, photographs, and ephemera that document the political, social, and economic history of the United States. An extensive resource for educators, students, and scholars, the Collection ranges from 1493 through the twentieth century and is widely considered one of the nation's great archives in the Revolutionary, early national, antebellum, and Civil War periods.

Founded in 1994 by Richard Gilder and Lewis E. Lehrman, the Gilder Lehrman Institute of American History is a nonprofit organization devoted to the improvement of history education. The Institute has developed an array of programs for schools, teachers, and students that now operate in all fifty states, including a website that features the more than 60,000 unique historical documents in the Gilder Lehrman Collection. Each year the Institute offers support and resources to tens of thousands of teachers, and through them enhances the education of more than one million students. The Institute's programs have been recognized by awards from the White House, the National Endowment for the Humanities, and the Organization of American Historians.

The Gilder Lehrman Institute of American History is a 501(c)(3) non-profit public charity supported through the generosity of individuals, corporations, and foundations. Donations are fully tax deductible.

GETTYSBURG NATIONAL MILITARY PARK AND THE GETTYSBURG FOUNDATION

The National Park Service administers Gettysburg National Military Park, established in 1895. The Park itself encompasses 6,000 acres of battlefield with more than 1,300 monuments dedicated to the soldiers who fought here. The National Park Service mission is to protect, preserve and interpret the Battle of Gettysburg and the Soldiers' National Cemetery.

More than one million people of all ages visit the Gettysburg National Military Park Museum and Visitor Center every year. Gettysburg is the most visited Civil War site in the National Park Service, with nearly half of visitors journeying here more than once to find inspiration and understanding.

Many come to explore the fields hallowed by the soldiers themselves—or to view artifacts in the Park's Museum and Visitor Center that weave the story of Gettysburg and give it meaning in context of the war. Some come to discover Gettysburg's lessons of leadership and sacrifice. Still others come to research the rich library collection or to trace their ancestors.

The Gettysburg Foundation has been the non-profit partner of the National Park Service at Gettysburg since 1989. It successfully has fostered lasting collaborations with academic institutions and private organizations through educational and leadership programs, facilitated extensive monument and land preservation projects, and funded acreage and property acquisitions deemed pivotal to the historical interpretation of Gettysburg.

Without any public funding, the Foundation operates the Park's Museum and Visitor Center—including the historic Cyclorama Painting, *"New Birth of Freedom"* Film and 12-Gallery Museum Experience—which provides an important sanctuary for visitors

to learn about a transformative chapter in American history. It has been designed to give visitors an understanding of the magnitude of the sacrifices made at Gettysburg through state-of-the art exhibits, powerful imagery, and interactive technology. It also is LEED Gold Certified (Leadership in Energy and Environmental Design), as determined by the U.S. Green Building Council, which sets voluntary standards for high-performance, sustainable buildings.

To date, the Gettysburg Foundation also has helped Gettysburg National Military Park acquire and preserve more than 500 acres of battlefiefld land; funded nearly a dozen major battlefield rehabilitation projects to bring the field closer to its 1863 appearance; secured assistance to preserve numerous monuments and cannons; provided for the development of cutting-edge and award-winning exhibits, educational programs and services; and provided more than 20,000 volunteer hours to preserve the Park's cultural and commemorative resources. And there is much more to accomplish.

THE UNFINISHED WORK
How you can help

In addition to providing key support to Gettysburg National Military Park for special events commemorating the 150th Anniversary of Gettysburg, the Gettysburg Foundation continues, in Lincoln's words, to complete the "unfinished work" of protecting, preserving and interpreting Gettysburg's legacy for future generations. We invite you to visit, explore and learn how you can join us in our mission to preserve and protect Gettysburg—this special year and all the years to come.

Gettysburg National Military Park

Write
Gettysburg National Military Park
1195 Baltimore Pike, Suite 100
Gettysburg, PA 17325-2804

Visit
www.nps.gov/gett

Call
717-334-1124

You can also visit us on Facebook, Twitter, iTunes and YouTube

Gettysburg Foundation

Write
Gettysburg Foundation
1195 Baltimore Pike
P.O. Box 4224
Gettysburg, PA 17325-4224

Visit
www.gettysburgfoundation.org

Call
717-338-1243

Donate
717-339-2150

You can also visit us on Facebook and Twitter